DOG YEARS

Library of Congress Cataloging-in-Publication Data available.

ISBN 978-1-4521-3745-2

Manufactured in China

Designed by Emily Dubin

10 9 8 7 6 5 4 3 2

Chronicle Books LLC
680 Second Street
San Francisco, California 94107

www.chroniclebooks.com

DOG YEARS

FAITHFUL FRIENDS, THEN & NOW

Amanda Jones

CHRONICLE BOOKS

SAN FRANCISCO

INTRODUCTION

I have the great fortune to work with what are, in my eyes, the most beautiful creatures on earth: dogs. In all shapes, sizes, colors, and personalities, the joy these creatures bring us is timeless.

During the twenty years that I have been photographing dogs I've had the opportunity to work with hundreds of them at various points in their lives and in many cases throughout their lives. From adorable mischievous puppies to wise old souls, capturing these moments is my life work.

A dog's life is a span that marks so much in our lives. We get them as puppies and they are cute and goofy, driving us crazy with constant chewing on furniture and shoes, as well as making a mess of the house. Then we teach them and they learn to behave better (sometimes). The connection over time deepens, and as our dogs age, the tides shift and we tend to learn more from their teachings—to relax, to be joyful, to throw caution to the wind, and enjoy the simple pleasures of everyday life. Life really is better with a dog by your side.

This book is about that time. A dog's life starts off small and then grows to include many different humans, other dogs, new tricks, and new experiences.

My inspiration for putting this book together came from my very first dog, Lily. Lily is a longhaired Dachshund. She came into my life after I began photographing dogs. When I met a trio of longhaired Dachshunds at one of my early shoots, I knew instantly that was the breed for me. It took a few years to be in the right housing situation where I could have a dog, but as soon as that opportunity opened up, I welcomed her into my life. What a joy it was!

Running into the middle of a girls' soccer practice at the local park and causing total havoc, chasing her on the beaches of Maine, and watching her chase after moths in tall grass were just a few of the pleasures she brought us in her early years.

Lily was with us for sixteen wonderful years. In that time my husband and I moved across the country and back. We bought a house, had a baby, and through it all dear Lily was there with us—passing the time, being by our sides, joining us in our adventures of life.

My time spent with these dogs on the set and in their homes has been an amazing journey and learning experience. I now feel that I am part dog-portrait photographer, part dog psychiatrist, and part dog trainer, all of it coming from years working with dogs and their owners. My shoots are about so much more than the photographs; they are about the dogs and the people who love them. They are about honesty and trust. There is a deep understanding that these are more than just animals. They are partners by our sides as we travel through life.

In working on this book, I rejoined dogs, couples, and families who I had worked with years ago. Some dogs had been lost to illness and accidents. Most are living amazingly long, happy lives in perfect surroundings. Owners and dogs had aged, become gray, wrinkled in the eyes, and less spry. The visual impact of comparing the young and the old varies greatly from dog to dog, just as it does from person to person. Some don't seem to age at all, yet others show the signs quite openly in their eyes, their jowls, and their gray hair. It is this semblance of ourselves and our souls in their eyes that gives us such a deep connection with dogs.

One thing that remains constant is the love people and dogs have for each other. That does not change, no matter how many dog years go by.

Lily

LONGHAIRED DACHSHUND

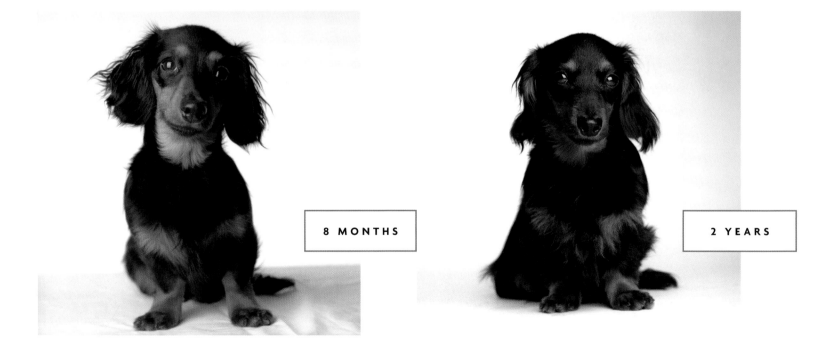

8 MONTHS

2 YEARS

Lily is a complex dog. A little aloof and independent, definitely self-serving, this little dog knows what she wants and doesn't give up until she gets it. She can charm the pants off anyone. I love how she poses the same way for each shoot we did together. Anything for a treat. Her favorite one is a raw baby carrot.

We call her "Last Word Lily Jones."

AMANDA JONES

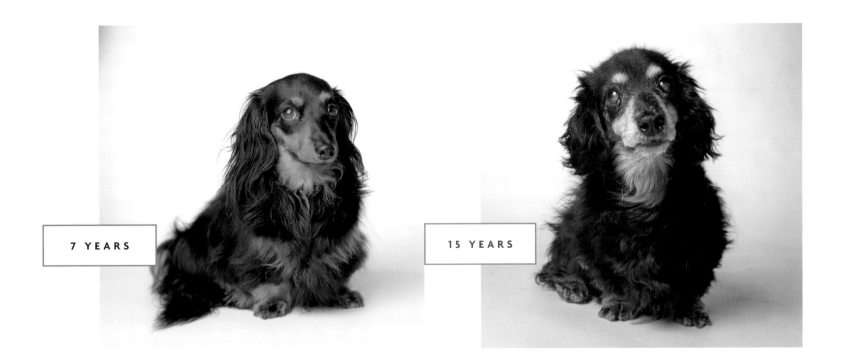

7 YEARS

15 YEARS

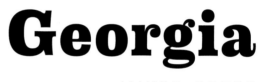

Georgia

MIXED BREED

I went to the pound near where I lived in Northern California and there was puppy Georgia. She was a bit of a mess but I fell for her immediately. I put in my application and that was that. I was 23.

Now I've had Georgia my entire adult life. She is my loyal companion, riding whatever wave I'm on. I got new apartments. I got new jobs. I got new boyfriends. Georgia is such a good barometer of things good and bad. She is always there for me, my dear little friend.

She's definitely part of me growing up and becoming the person that I am today. She and I discovered San Francisco together. She needed such long walks that we would walk all over the city. We moved to Los Angeles when she was a senior citizen and she loves the warm weather. I think it has given her a few extra years, sitting out on the warm patio smelling the flowers.

AMANDA NELSON

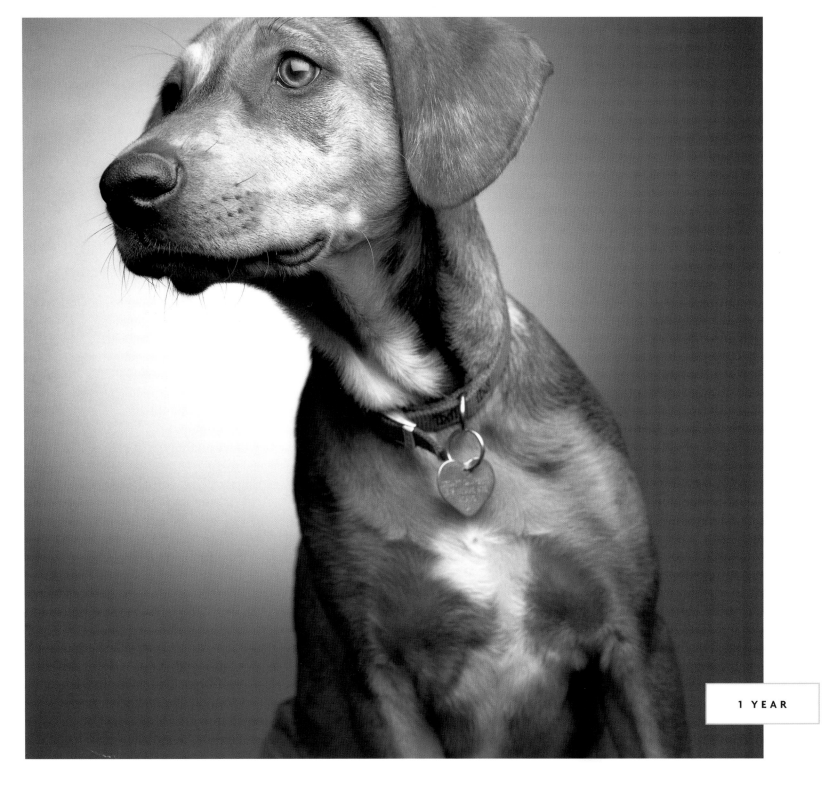

1 YEAR

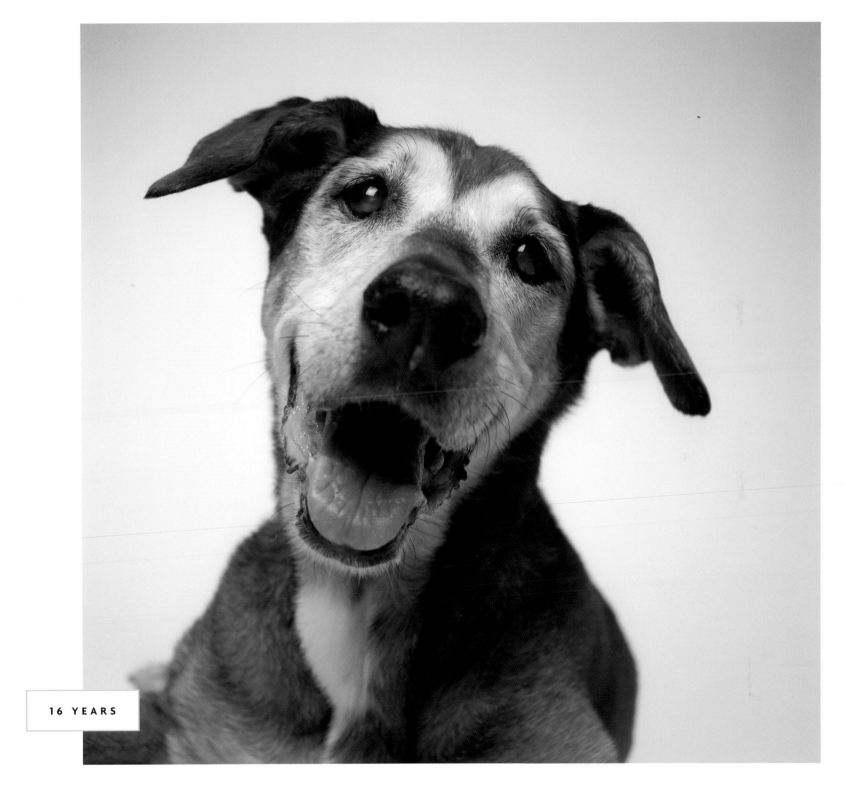

16 YEARS

Corbet

LABRADOR RETRIEVER

In my family, we always had male dogs. To change things up, I decided I wanted a little girl dog. And Corbet is every bit of that, my little girl.

When she was young, I found out she had elbow dysplasia. She had surgery at six months and I was like, "Oh, my little girl is really tough." We got really close during her rehab. It was like extra bonding working together to get her better. None of it slowed her down.

Now she is 11 years old and she is slowing down a bit. She needs a little moral support getting up the stairs, but she does her little bunny hop and I cheer her on.

KIM WRIGHT

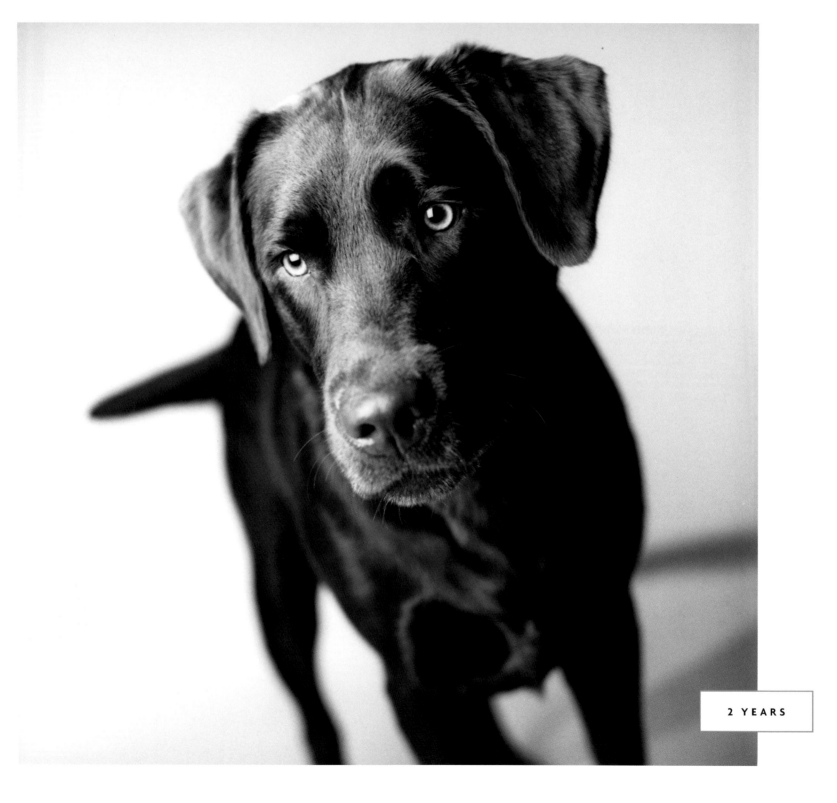

2 YEARS

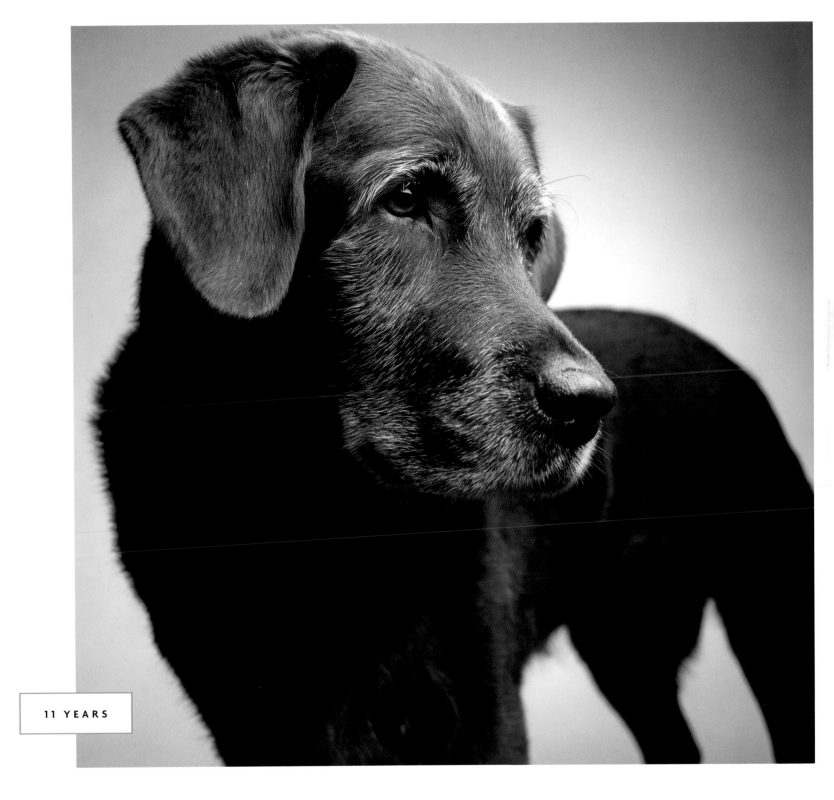

11 YEARS

Gracie

POODLE

Gracie's personality has changed over time. When she was a puppy, she was an absolute terror. The breeder picked her out for me, telling me how sassy she was. She wasn't kidding.

This puppy was so rambunctious. She destroyed everything. We dropped out of puppy school and she was expelled from three different day cares. You know how when you have kids and the school would call and tell you about the trouble your child is causing? Well, I would be at work and I would get calls from the day care telling me I had to come and pick up Gracie because she was being impossible.

She was about five years old when she calmed down and stopped her crazy ways. She is an amazing dog. She just loves life and won't let anything get in her way to express her joy. A smile is always on her face.

AILEEN ARRIETTA

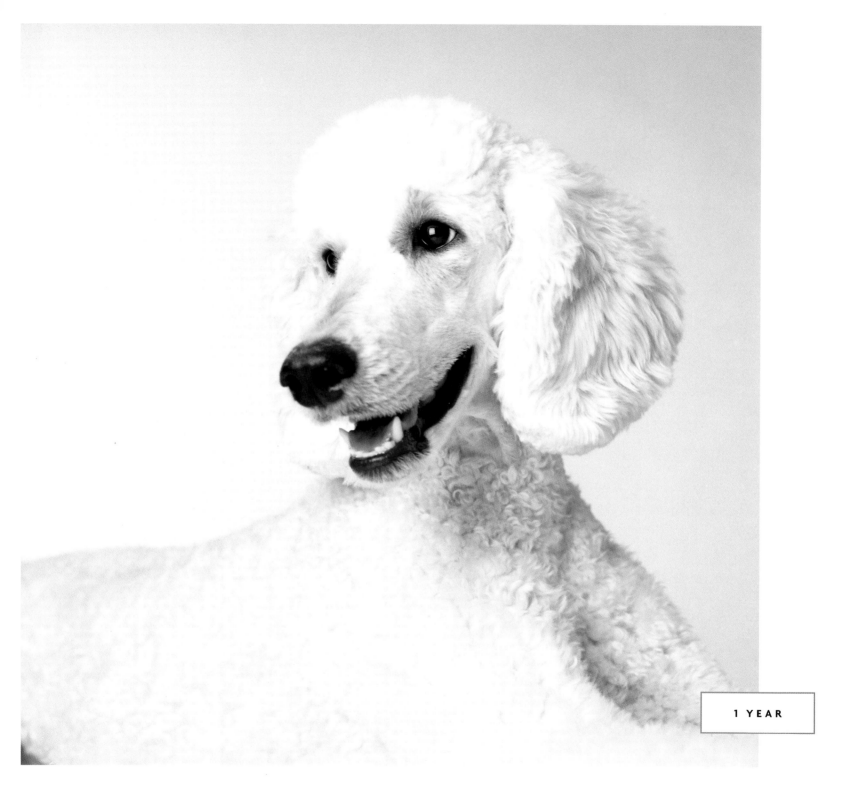

1 YEAR

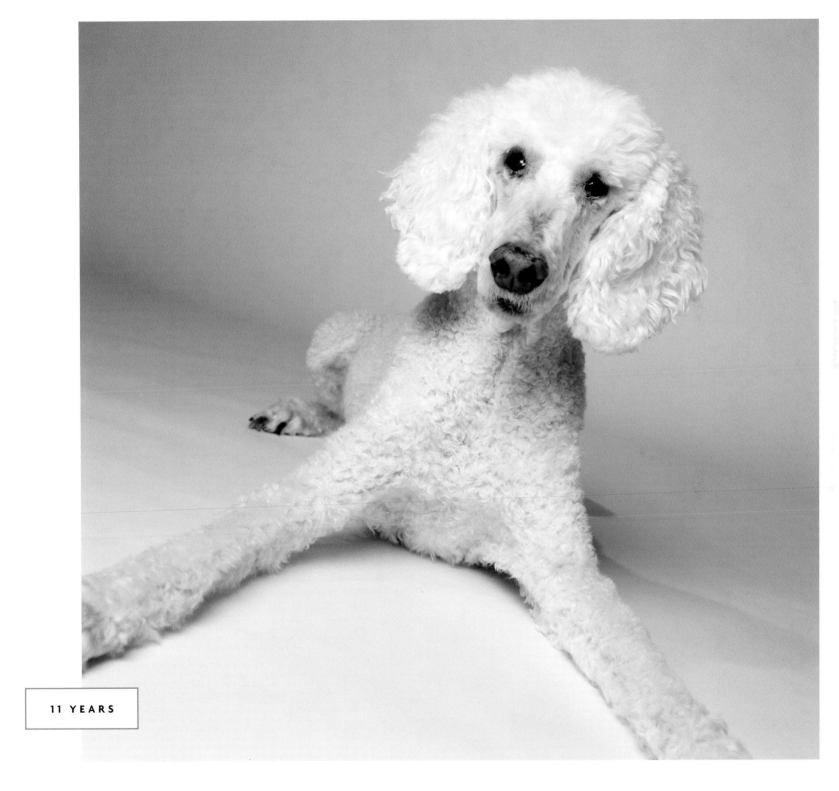

11 YEARS

Gus & Liza

MIXED BREED & ENGLISH POINTER

It's hard to describe the consistency of their presence in our lives. We didn't expect it when we first brought Gus home. It was hard to look into the future and see how important they would become to us. Now we can't imagine our lives without them. We are closer to our dogs than we are to a lot of humans. They have been the most constant thing in our lives in the past twelve years.

CHRIS BOUDEWYNS

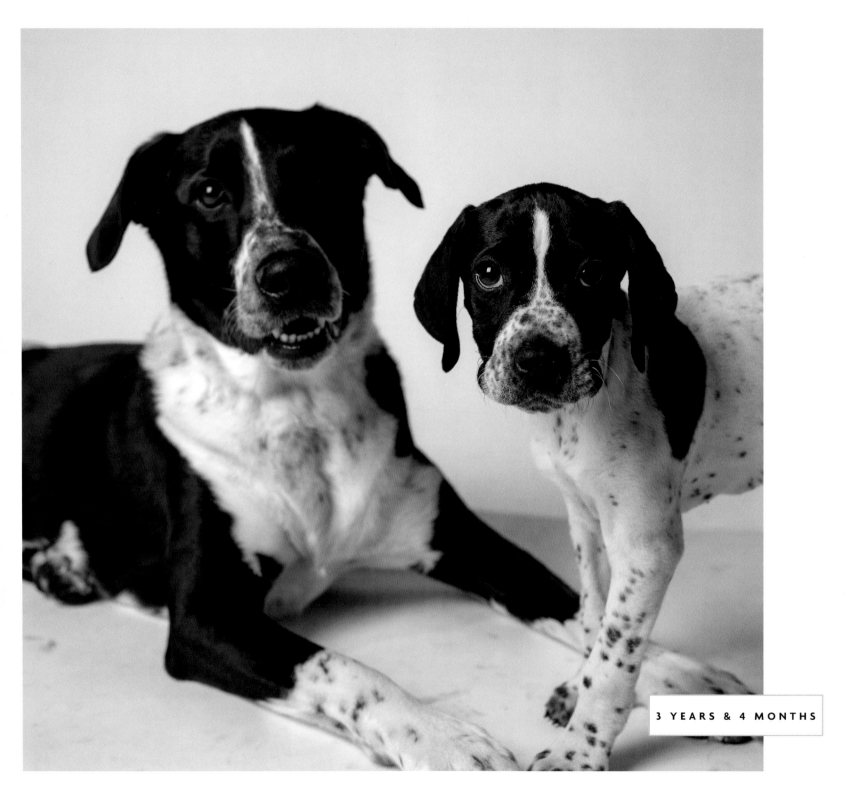

3 YEARS & 4 MONTHS

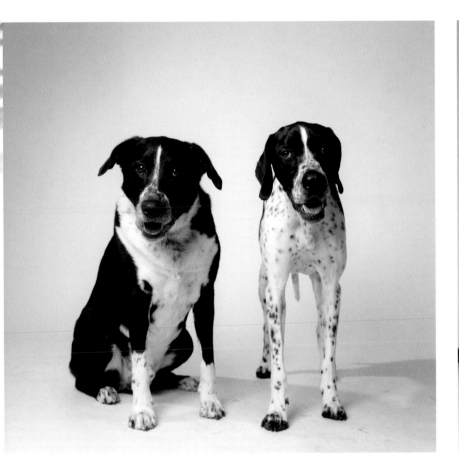

5 YEARS & 2 YEARS

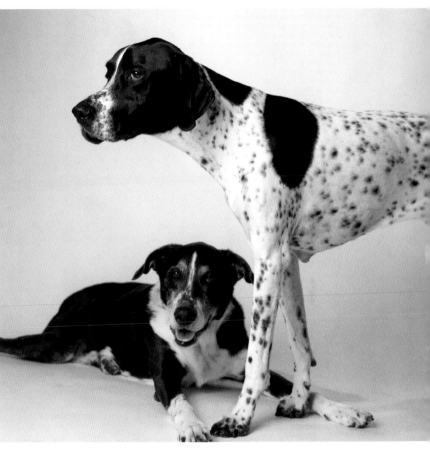

10 YEARS & 7 YEARS

Maddy

MIXED BREED

Maddy and I stumbled into adulthood together, as I adopted her during my senior year at Duke. While raising each other, we faced my hospitalization for complications from leukemia, a year of rehabilitation, my parents' divorce, moving to New York, graduate school, and her diagnosis and treatment for lymphoma. It's the two of us against the world.

I always tell her, "You are my bestest friend in the whole wide world!"

CLARE MATSCHULLAT

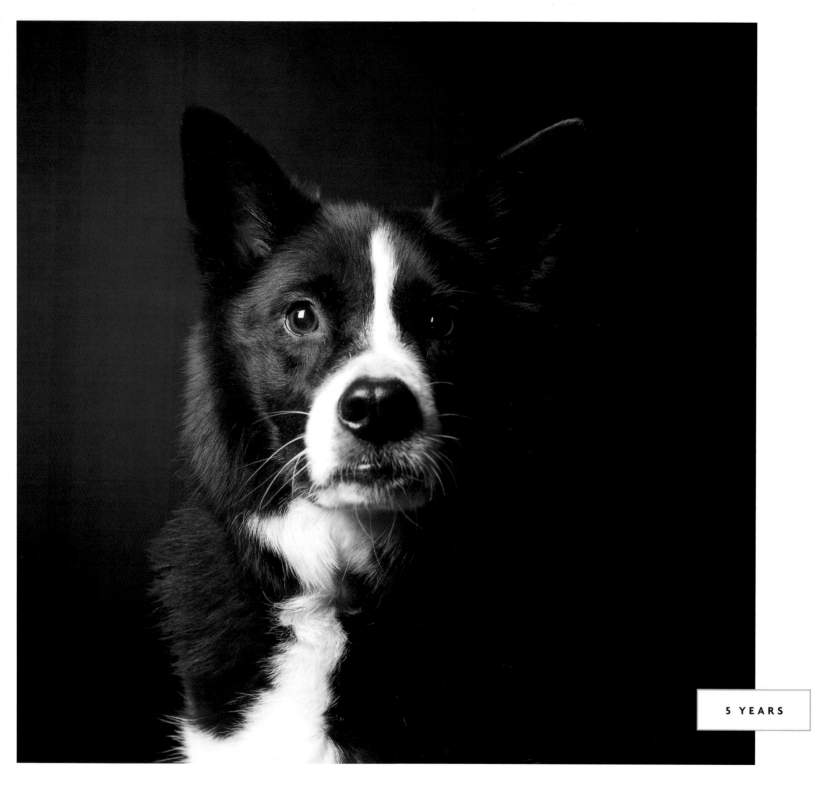

5 YEARS

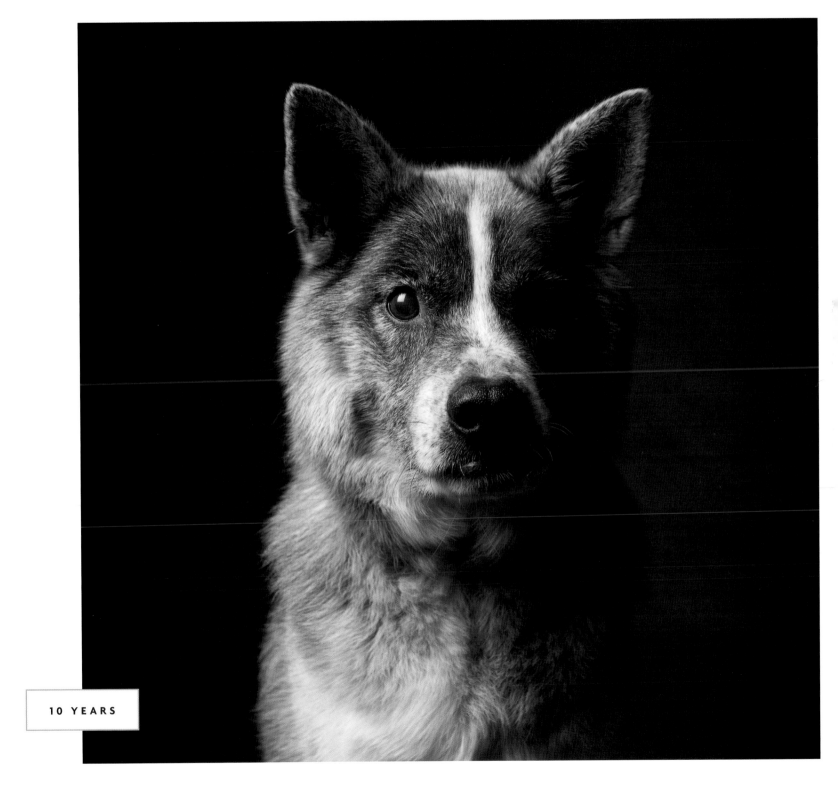

10 YEARS

Poppy

BASSET HOUND

What's so moving for me about Poppy is that she helped me get through my heart surgery. When I came home from the hospital, she got into bed with me and curled up on my right side. She was really nurturing. When you are that sick and you just don't know what is going to happen to you, having someone so real next to you, reminding you that, really, it's not so bad, that you're alive and you have this animal next to you who loves you, that's all that really matters. She truly got me through.

HUNTER KERR RUNNETTE

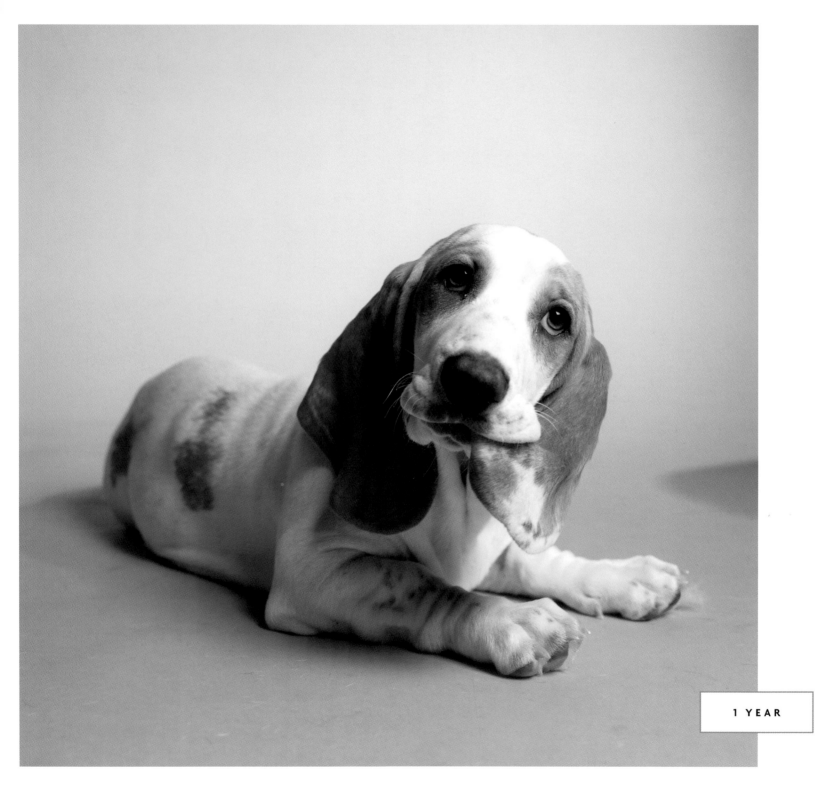

1 YEAR

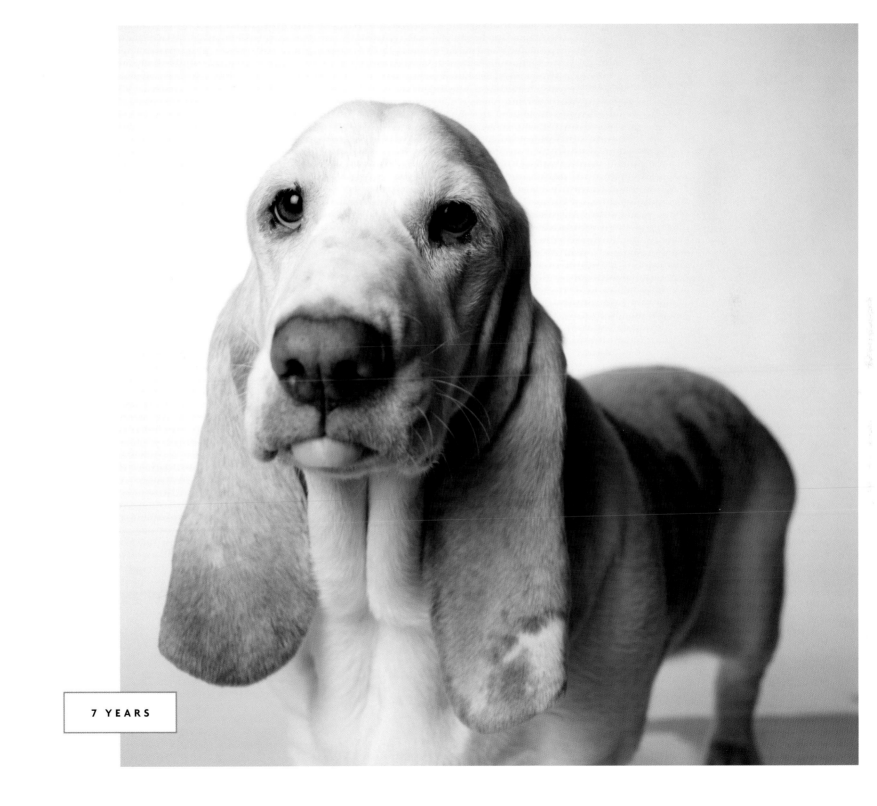

7 YEARS

Rufus

COCKAPOO

Rufus is a rock star of a dog. He is tough and he has got attitude. With his huge tongue, he reminds me of Gene Simmons. He even has a rock star name: Rufus Dwayne.

I look at him and I say this all the time, "You are just *good lookin'*!" I must have said it a million times. He makes me fall in love with him every time I see him.

STACEY DELARIOS

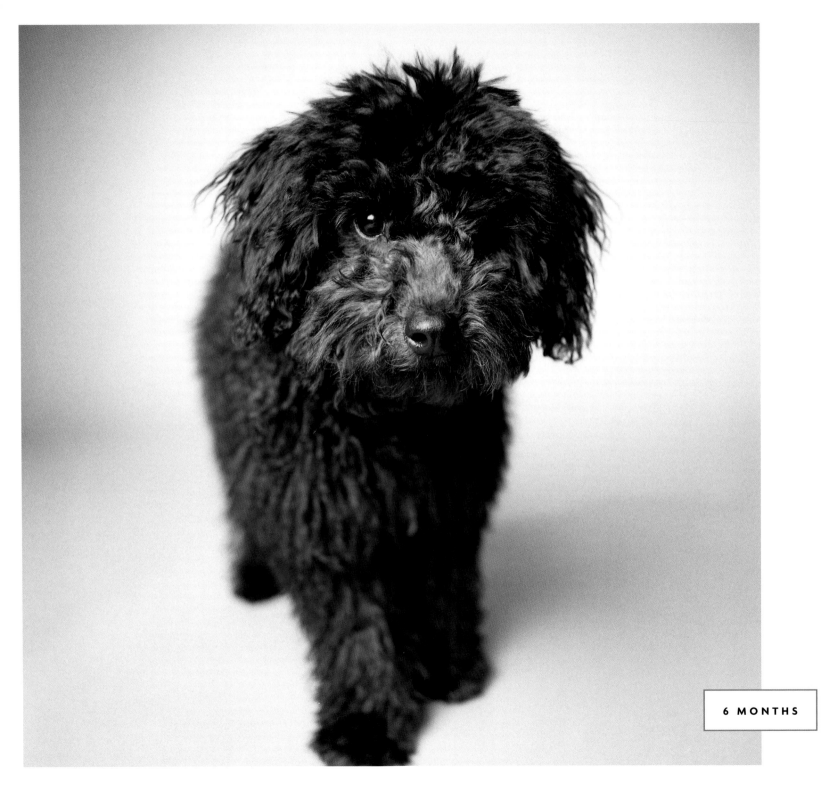

6 MONTHS

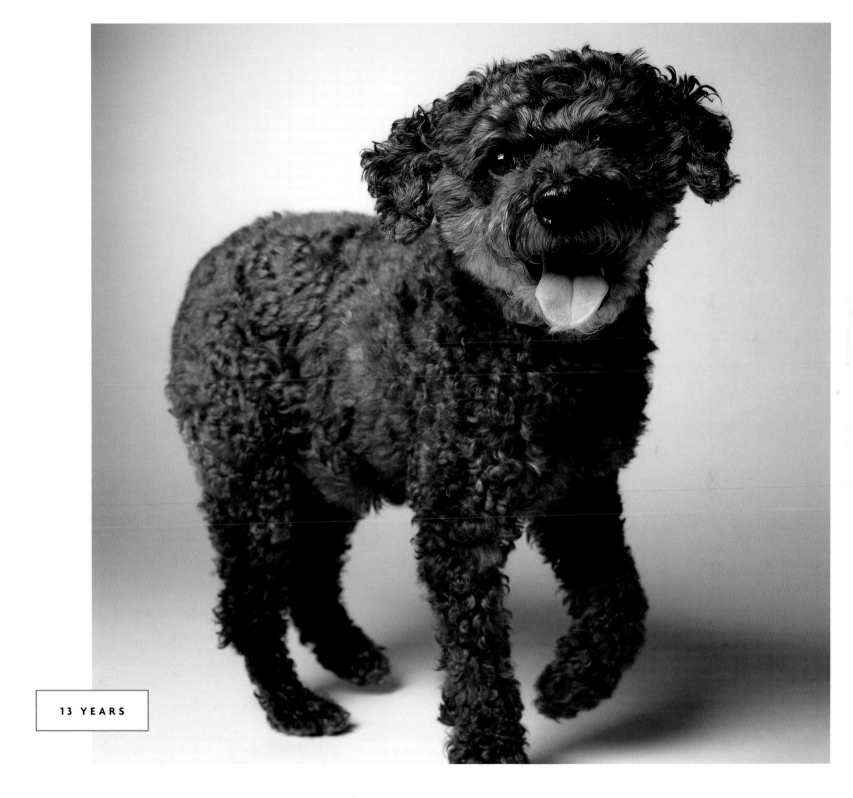

13 YEARS

Olive & Mochi

PUGS

I've always had a happy life. But when I look back at the ten years we have had the dogs, that happiness is multiplied like a thousand times. It's funny, you think you're happy and then someone or something comes into your life and you think, "Oh, I am so much happier now." They are such a huge part of my life.

LISA WOODRUFF

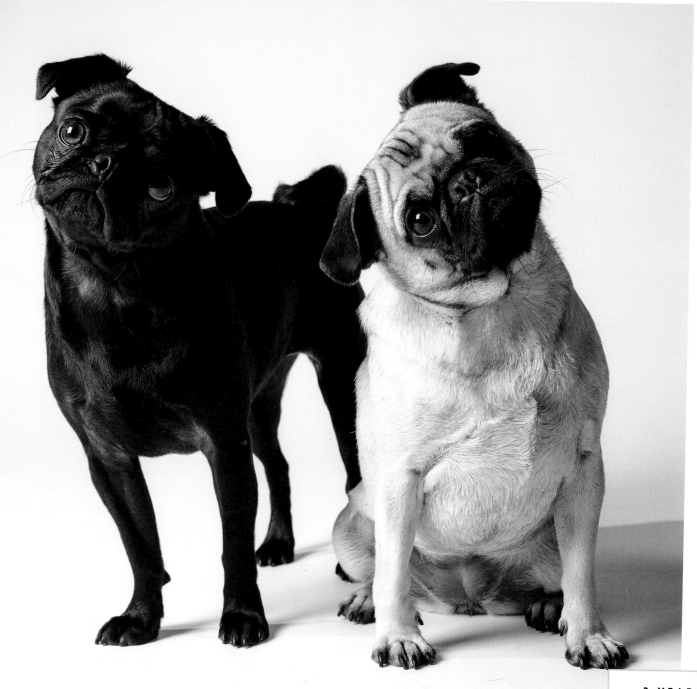

2 YEARS

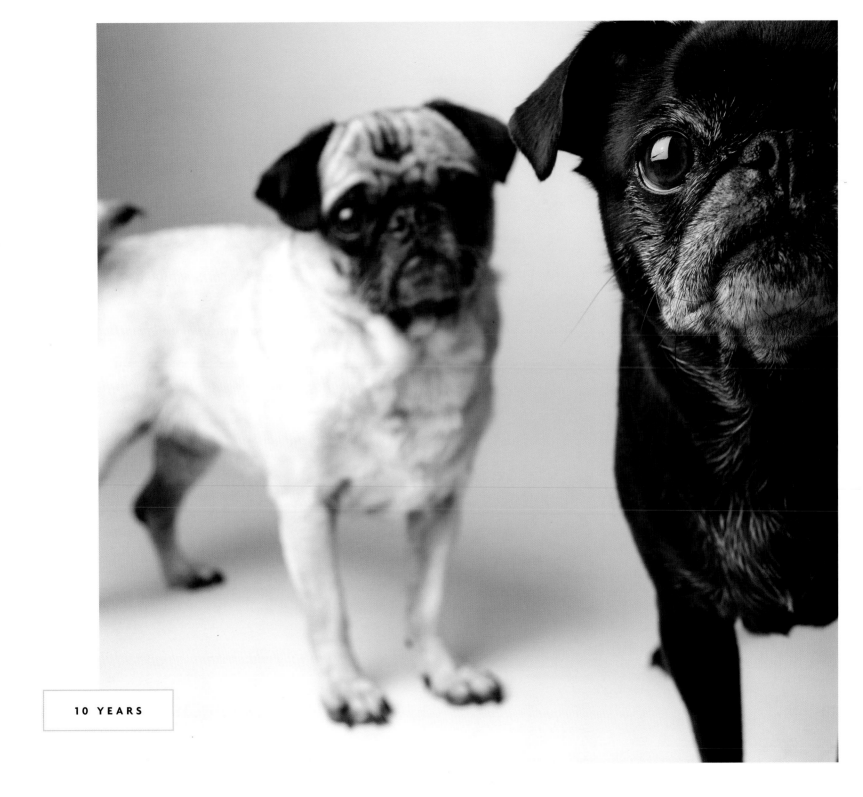

10 YEARS

Rumer

VIZSLA

Rumer is such a happy little soul. She fit instantly into our pack of two other Vizslas and a Chihuahua. She has a very calming influence on other animals. Rumer is a caretaker. She had one litter of puppies and she was a pushover mother. Her puppies could get away with anything and she would just sit there and watch them like, "Aren't they just adorable!"

She does this thing where she sits right next to you and puts her cheek next to yours and just sits there, cheek to cheek. I don't think we've ever had a night together where there wasn't a part of our bodies touching each other. She is my friend and my partner.

JANET GALANTE

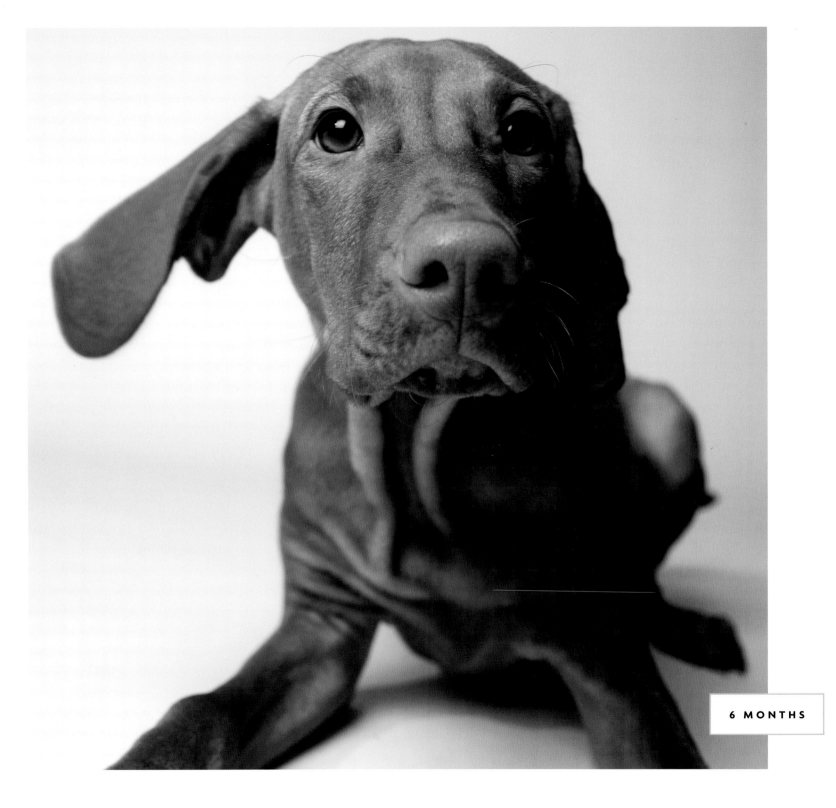

6 MONTHS

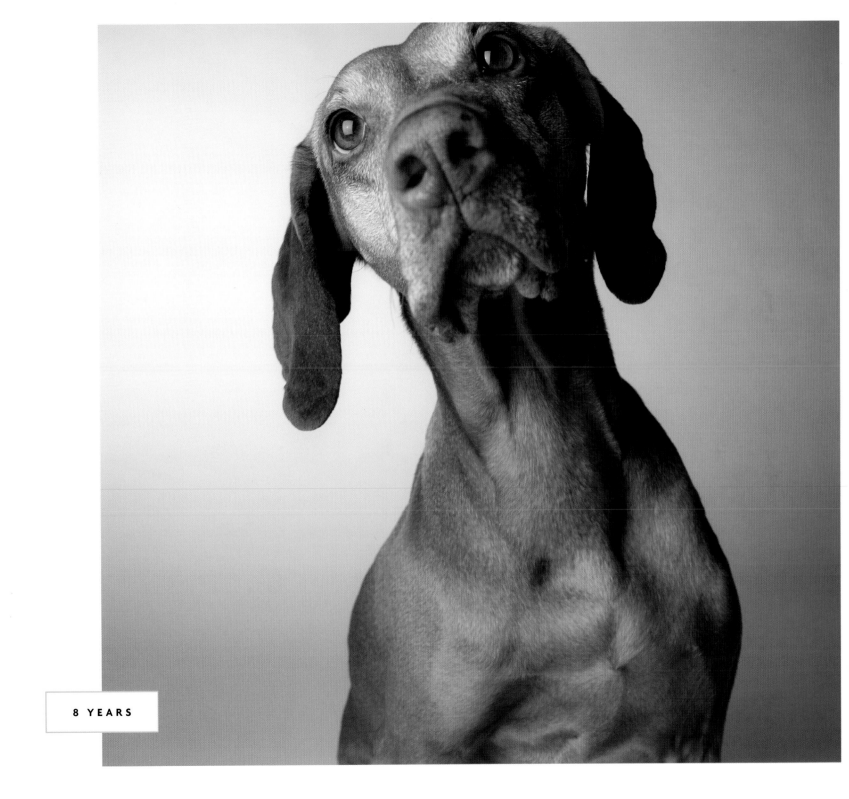

8 YEARS

Abigale

SHIBA INU

I never even knew a Shiba Inu before Abby came along! Being from Alaska, I always had Huskies, but I wanted a smaller dog. It was a leap of faith but ended up being a perfect match. I love her two-tone coloring and stubborn attitude.

She runs the household. We call her Alpha Girl. We do pet therapy together. She really enjoys being around people and helping them.

PAM TREECE

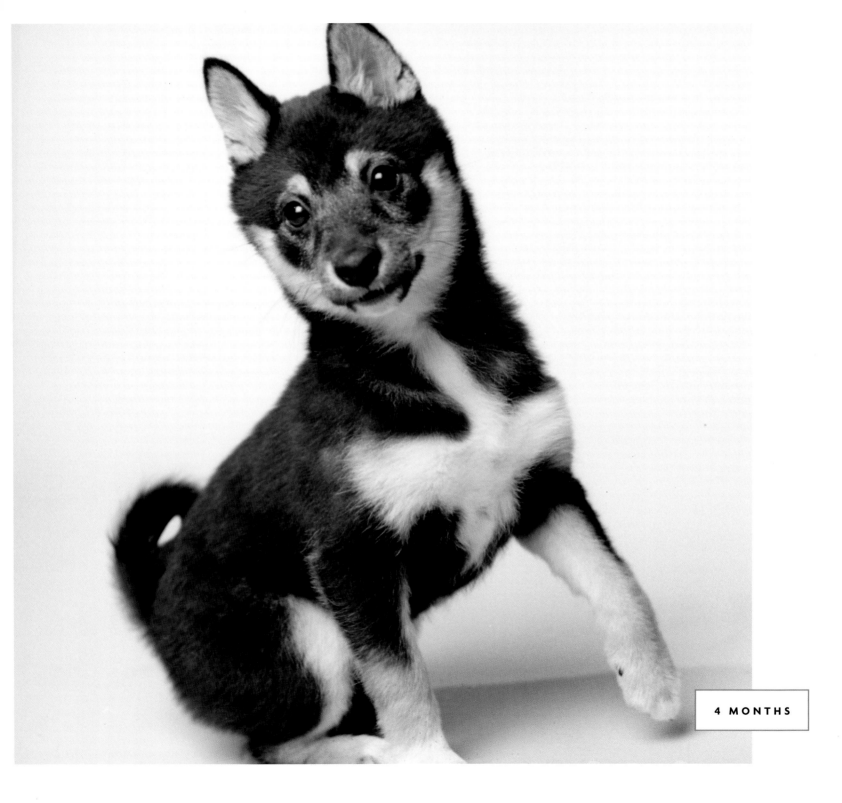

4 MONTHS

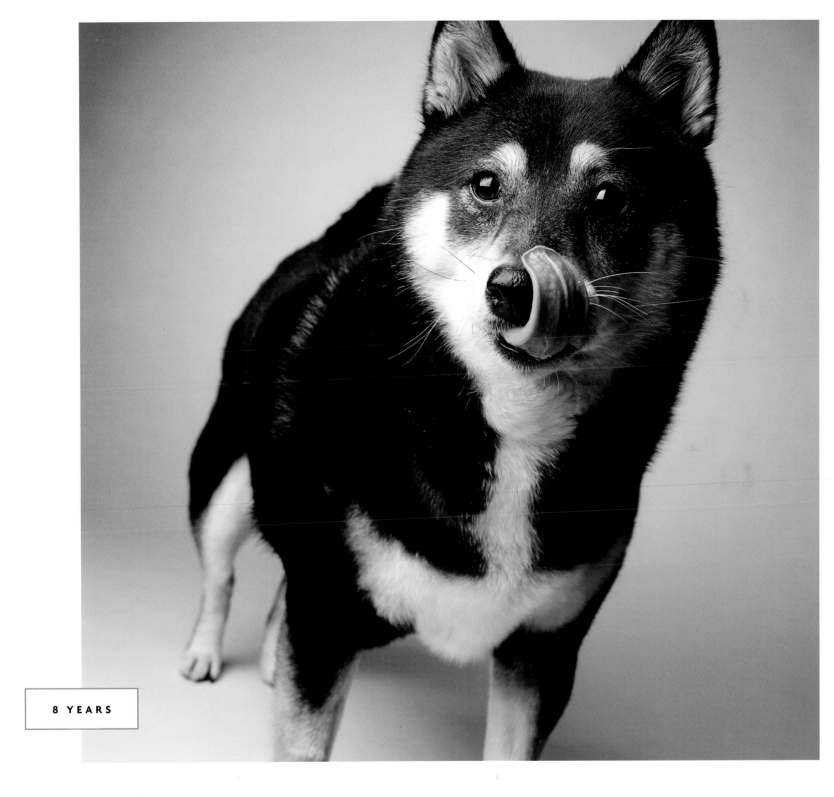

8 YEARS

Sydney & Savannah

BEAGLES

We got Sydney first. Savannah followed almost a year later. They are ten months apart. Two beagles was a condition for marriage. After Sydney's crazy puppy days, Chris tried to say no way to a second one. To no avail!

We knew they would be happier with two. They are incredibly loving and attentive. They are willful and entertaining. They are the clowns of the dog world. They have been a huge part of our lives, these two. Everyone around town knows them. They call them "The Girls." We can't imagine having any other breed of dog.

JUDITH FORREST & CHRIS CHAFFIN

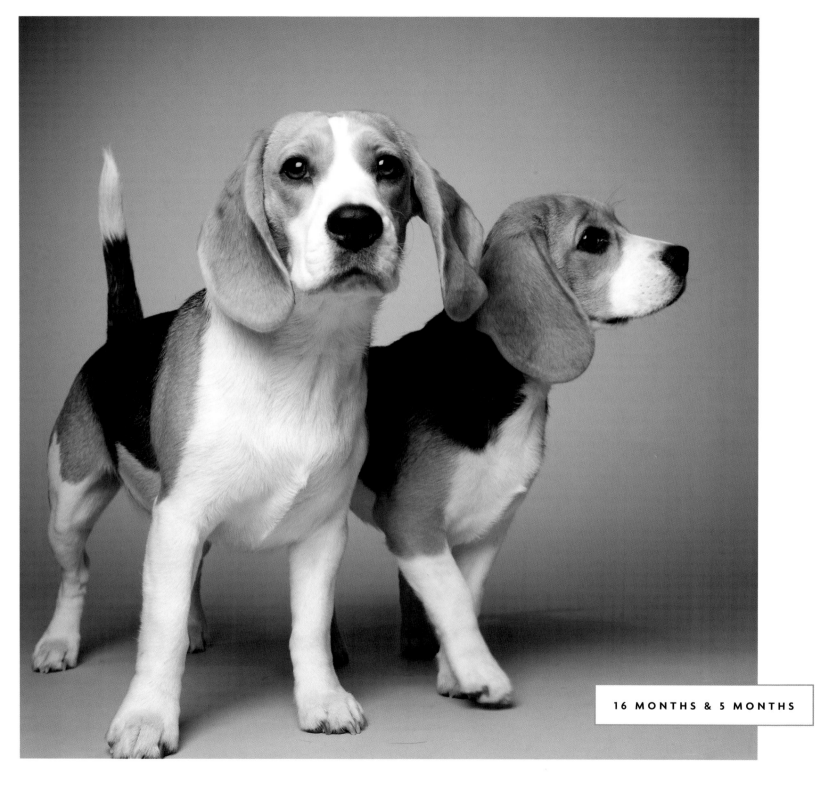

16 MONTHS & 5 MONTHS

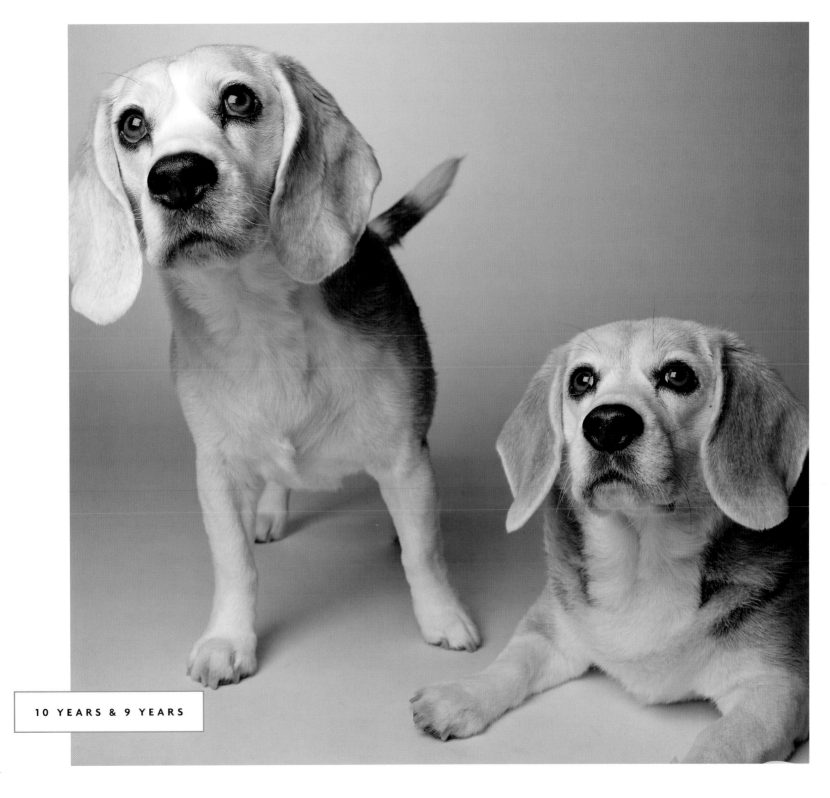

10 YEARS & 9 YEARS

Zamboni

MIXED BREED

I was working heavily in the tech field in the Bay Area when I realized that I needed a dog in my life. So I cut out of work early one day and went to the Humane Society.

My first round through the shelter I didn't even see him. I had chosen another dog and went to talk to the office about adopting that dog. The office was really busy so I decided to take another walk through the shelter. Zamboni was at the end of the row of kennels and he was just making a racket, which is not like him at all. He is the most mild-mannered dog.

It was like he picked me at the shelter. Not the other way around.

PAUL HEBERT

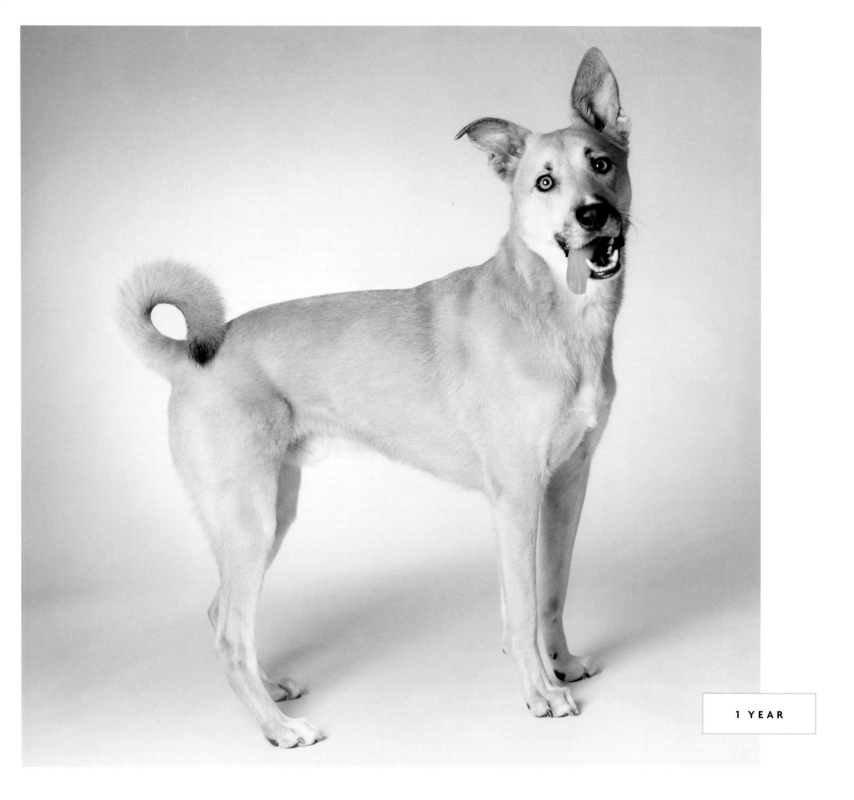

1 YEAR

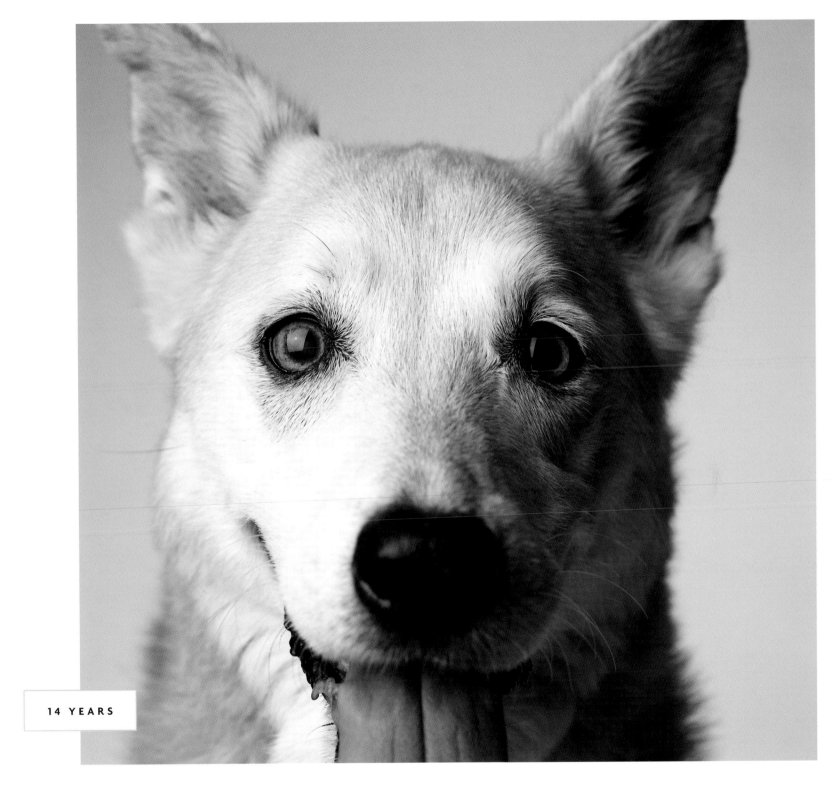

14 YEARS

Violet

LONGHAIRED DACHSHUND

She is such a shy little girl. We wanted a friend to keep our other Dachshund, Sweet Pea, company. Whenever the doorbell rings, Sweet Pea runs to the door barking and Violet hides in a back room, peeking around the corner from the hall like, "Who's here?"

JOAN GARVERICK & SANDRA ORR

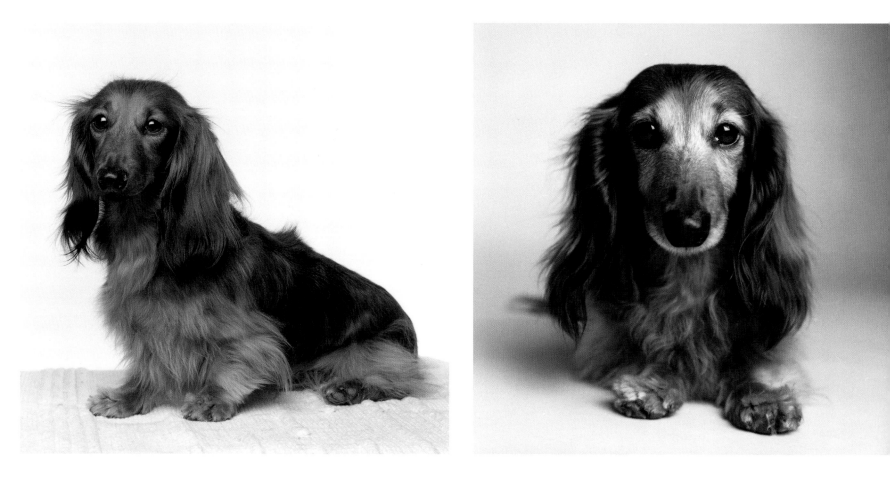

2 YEARS

9 YEARS

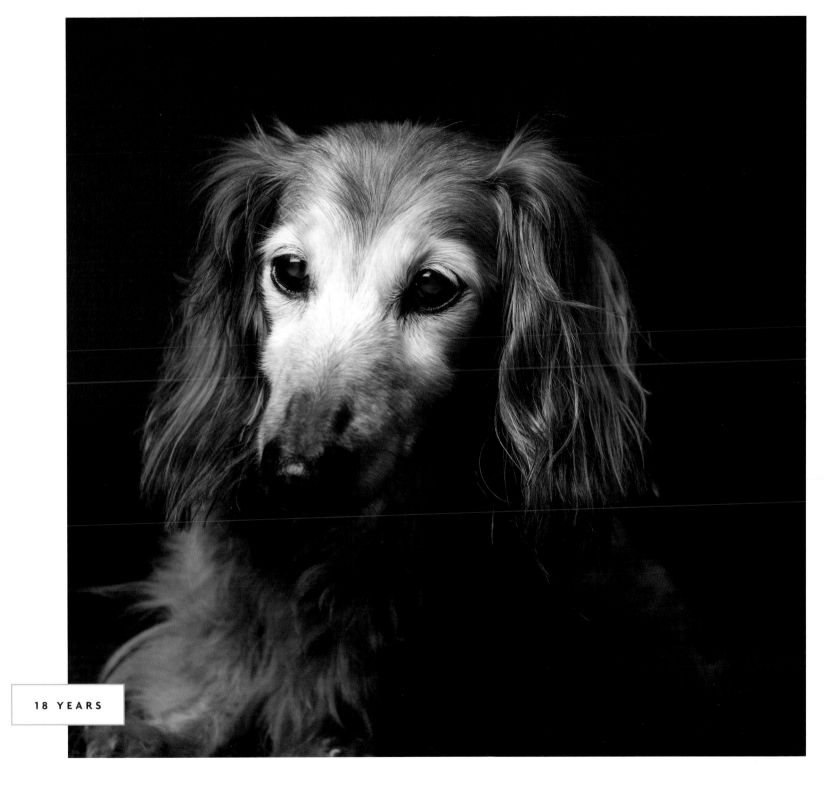

18 YEARS

Winston & Lola

BOXERS

Lola was always the mischievous little sister and a sweet free spirit. She once wandered off a mile away and, fortunately, this nice guy had the sense to realize she was out of place and put her in his garage.

Winston is the sensible and proper big brother. He just wants to please everyone. Lola would egg him on until he relented and would join her in her mischievous ways. They complemented each other so well.

We couldn't believe Lola would be the one to go first. Life has gone full circle. Now it's just Winston, like it was in the beginning. He is the center of attention, which I think he likes, being an older gentleman.

COURTNEY & JOE GOLDSMITH

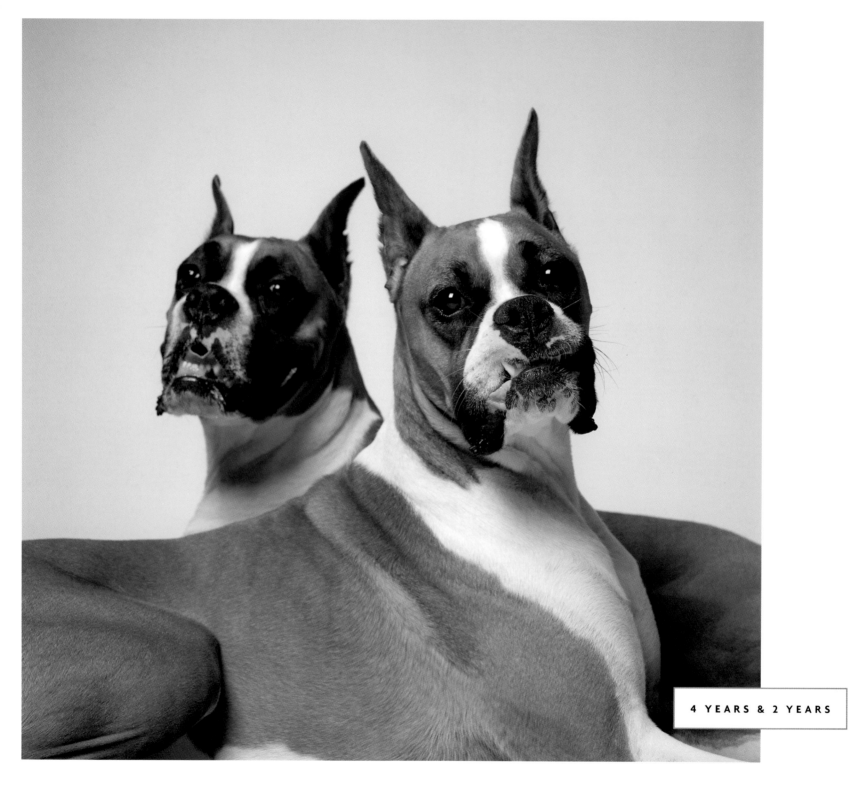

4 YEARS & 2 YEARS

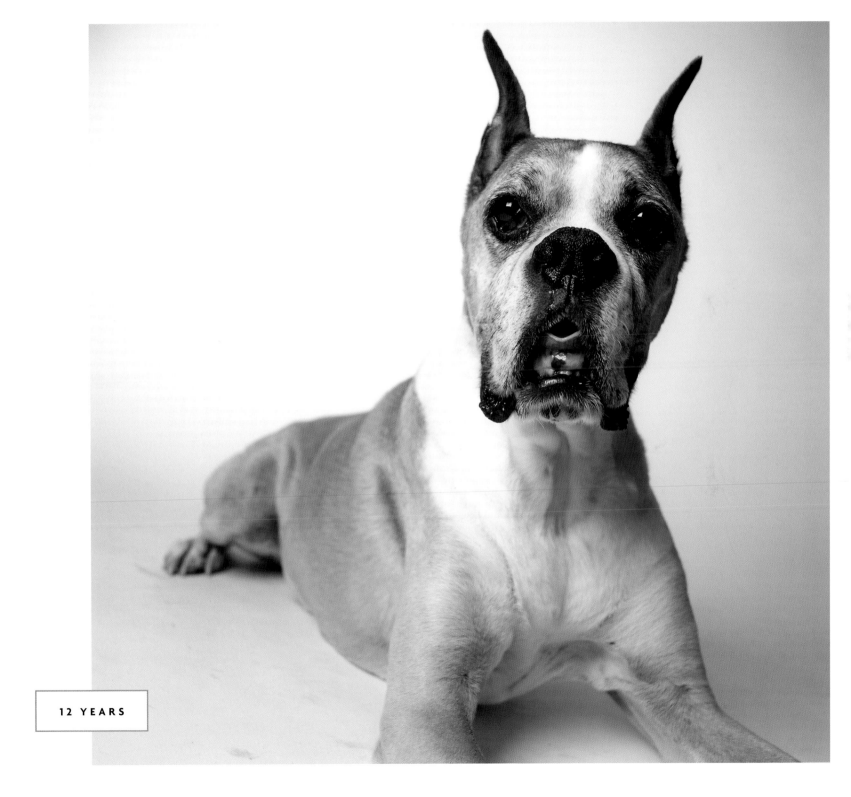

12 YEARS

Vasco

MIXED BREED

Vasco is charming, funny, and the best companion I could ever ask for.

However, and I mean this with the most love possible, he can definitely be a jerk. If he doesn't get his way, he has a look that he gives me, as if he's thinking "I could eat you in two bites." If I try to make him head home from a walk before he's finished, he lies down on the sidewalk and goes limp so that I can't stand him back up.

He is such a character, with a GIANT personality. He is truly the best dog ever.

KAREN HOCK

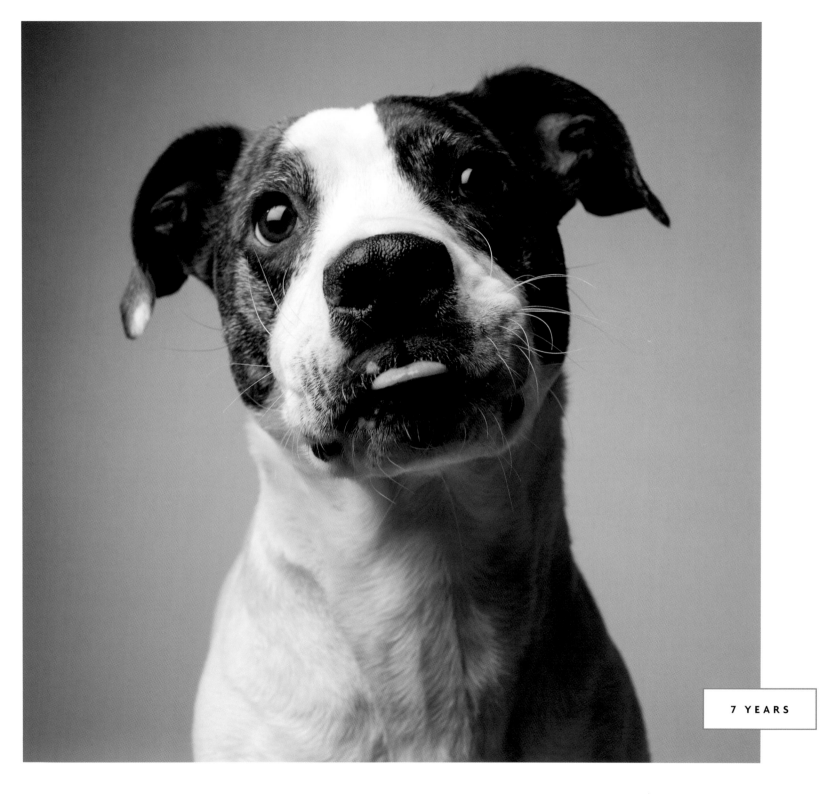

7 YEARS

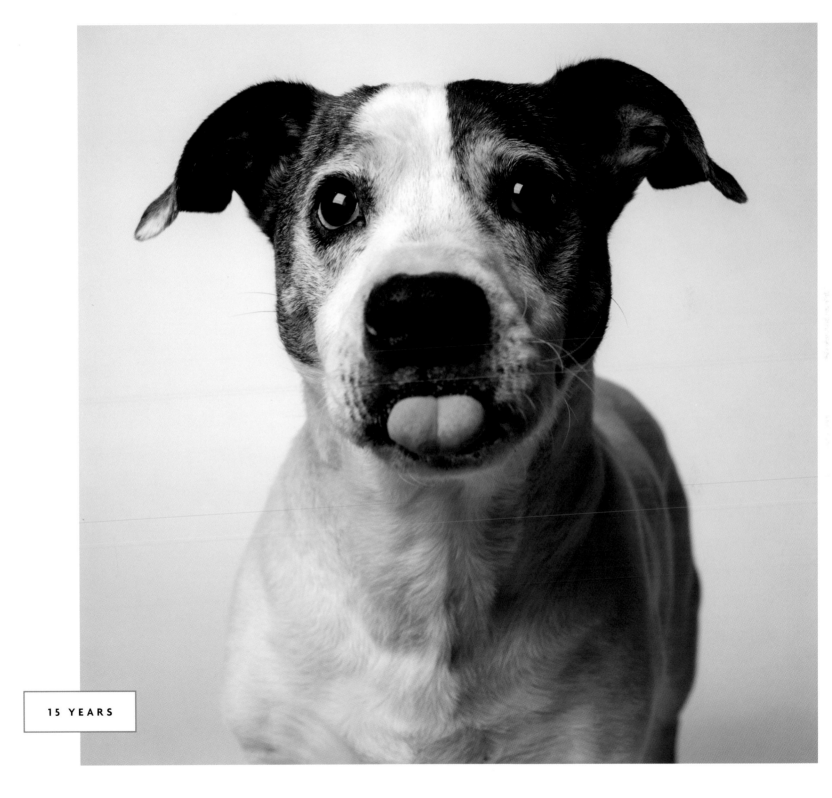

15 YEARS

Halle

YORKSHIRE TERRIER

I originally picked Halle out for my sister. I brought her home to my sister's house and she said, "Oh, I absolutely cannot have a puppy!" So I found myself caring for Halle—all three pounds of her. I learned instantly what it was like to have a dog. We bonded right away and have been together now for thirteen years.

I really wanted her to have good "dog" experiences so we started traveling and exploring many places together—hiking trails, beaches, dog parks. We love to do things together. I have opened myself up to new experiences because of her.

Halle lives in the moment and she has taught me that there is so much more joy and life to be lived right now rather than worrying about the past and the future. It doesn't hurt that she is so darn cute. She draws people in. She has made my life fuller in so many ways.

MARY DE WYSOCKI

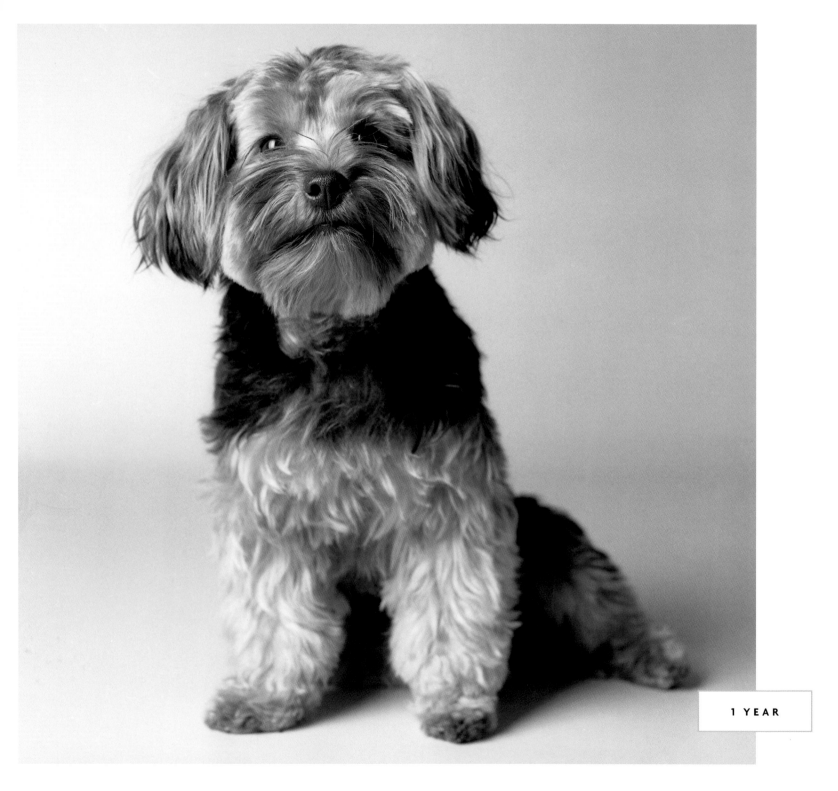

1 YEAR

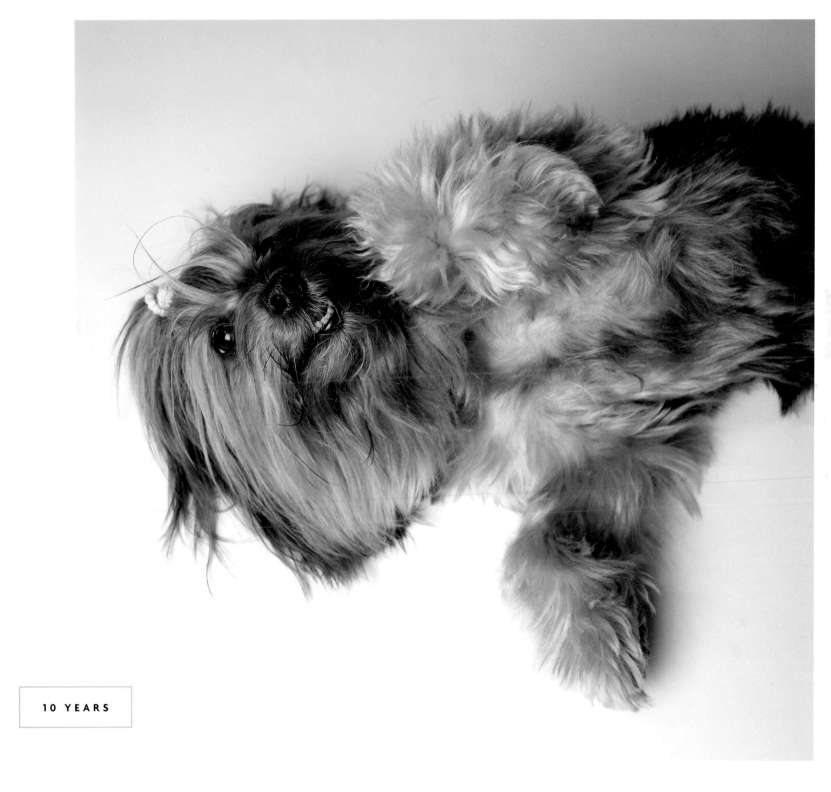

10 YEARS

Maggie

GOLDEN RETRIEVER

Maggie could have been a great hunter, had I been into such things. Instead she focuses on tennis balls. From day one, she has been simply obsessed with the tennis ball. I never taught her to retrieve, she came programmed ready to go.

Maggie started her life in a puppy mill. She has some serious health issues because of that, but her survival spirit keeps her strong. Ten years into our life together, I don't even have to say anything to her; we have this amazing nonverbal connection. She knows exactly what is going to happen next, even before I do! She is truly my best friend and unwavering companion.

MOLLYE WOLAHAN

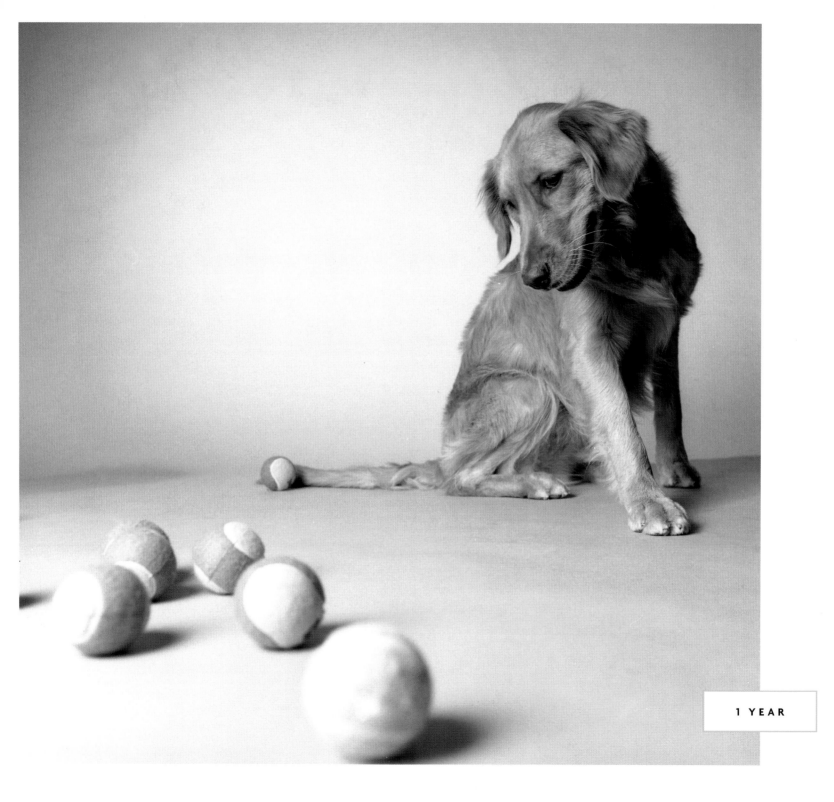

1 YEAR

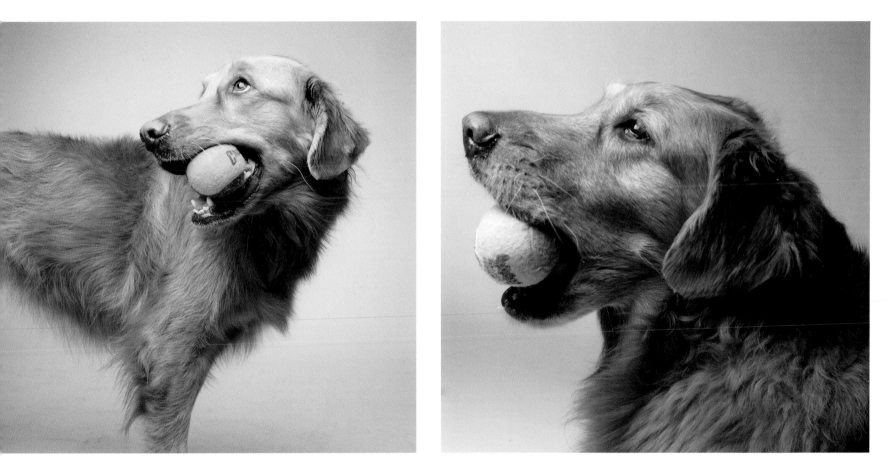

3 YEARS 10 YEARS

Tyson

MIXED BREED

We rescued Tyson. The first time I ever saw him was at a local adoption event. I remember walking by him and I thought he might be older, maybe four or five. He kept to himself. I was instantly drawn to him. I took his flyer home and shared it with my husband who told me he just wasn't ready for a dog.

Well, later that summer, we took a trip and shortly after we returned home, we had to head out to the supermarket to restock. We pulled into the parking lot and the same rescue group was having another adoption event. Right in front of us was Tyson. I couldn't believe here he was again. So we put in our application and took him home. It's hard to put into words how much he means to us. I feel so lucky.

It was meant to be.

MAURA SEMMES

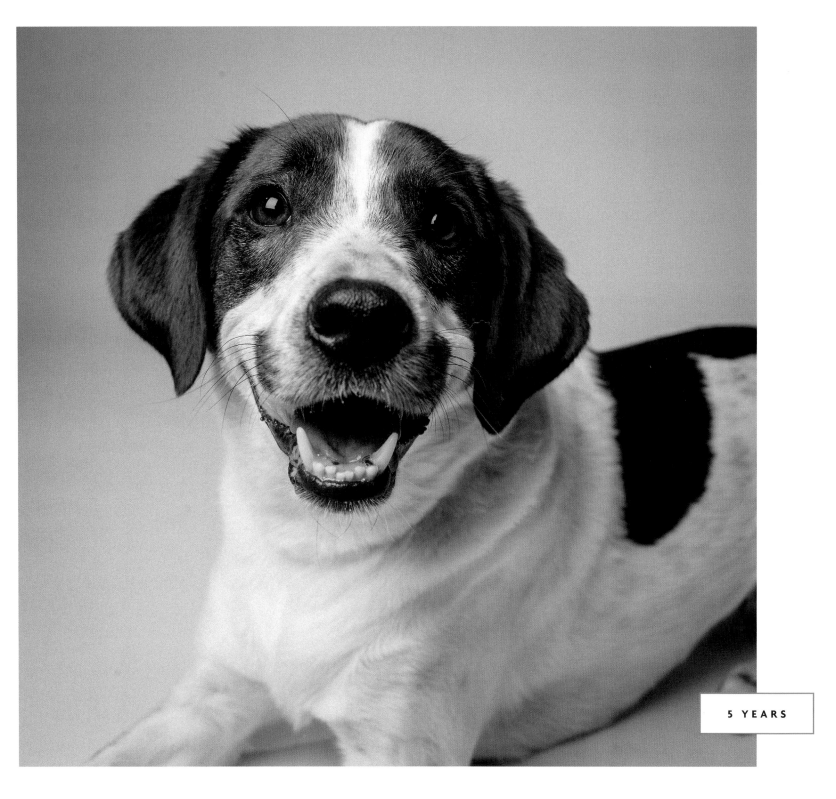

5 YEARS

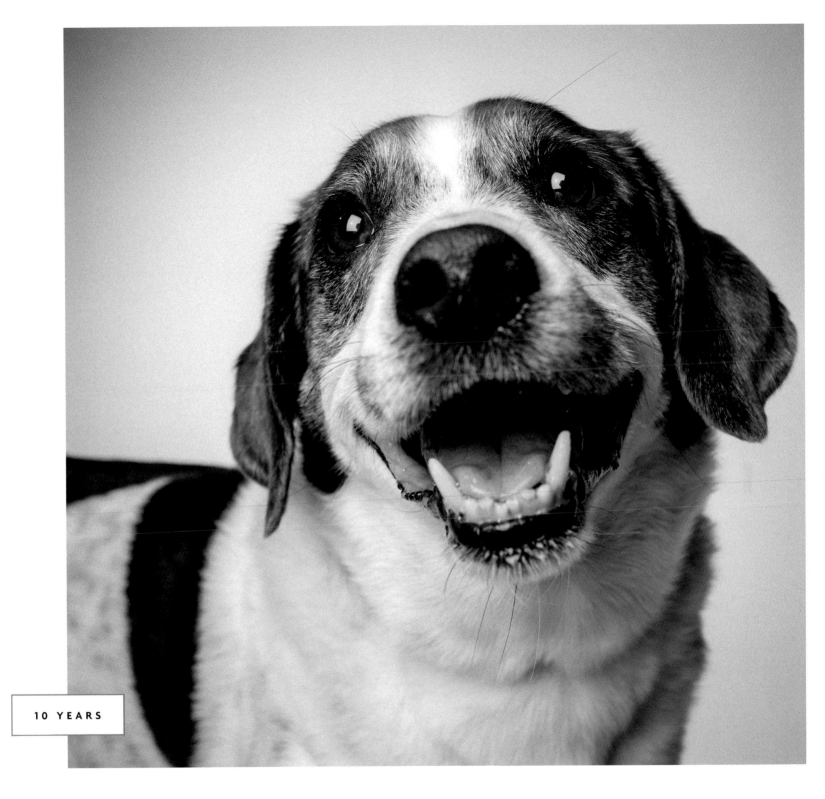

10 YEARS

Maddie & Elle

LABRADOR RETRIEVERS

Madison came first and she is a joy. She was the beginning of dogs in our lives and the one who really set the standard. Six months later we found Miss Elle. They are such different dogs, but each knows her place. Madison is the big sister, but Elle is the braver of the two.

It is beautiful to witness their relationship. When we look at these photos we think, there it is—right in front of our eyes is their relationship, captured on film. They love each other so much.

SCOTT LETCHER

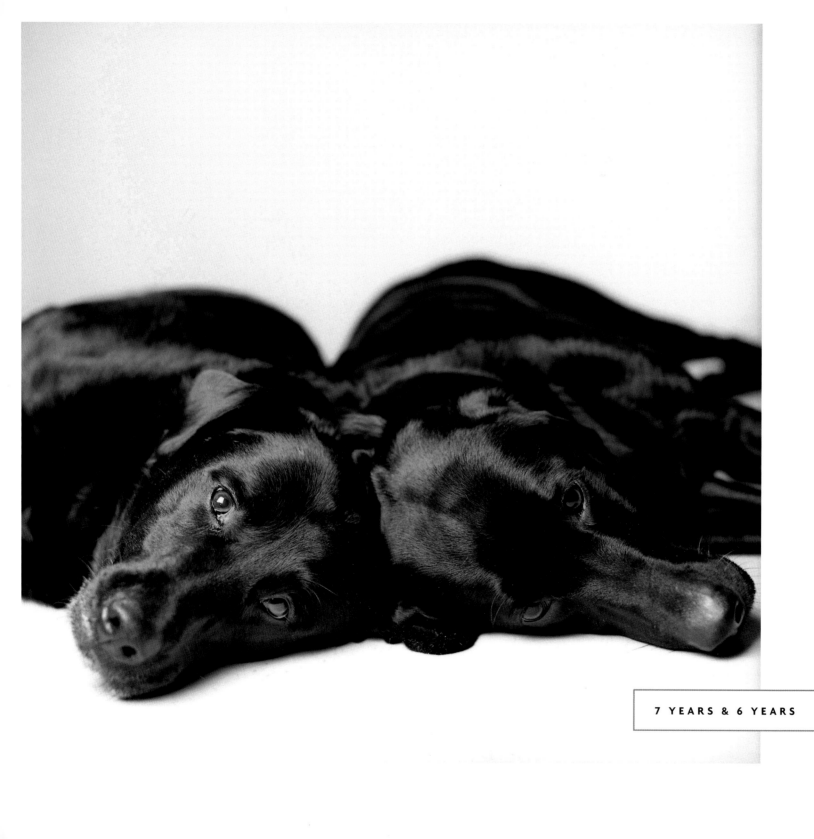

7 YEARS & 6 YEARS

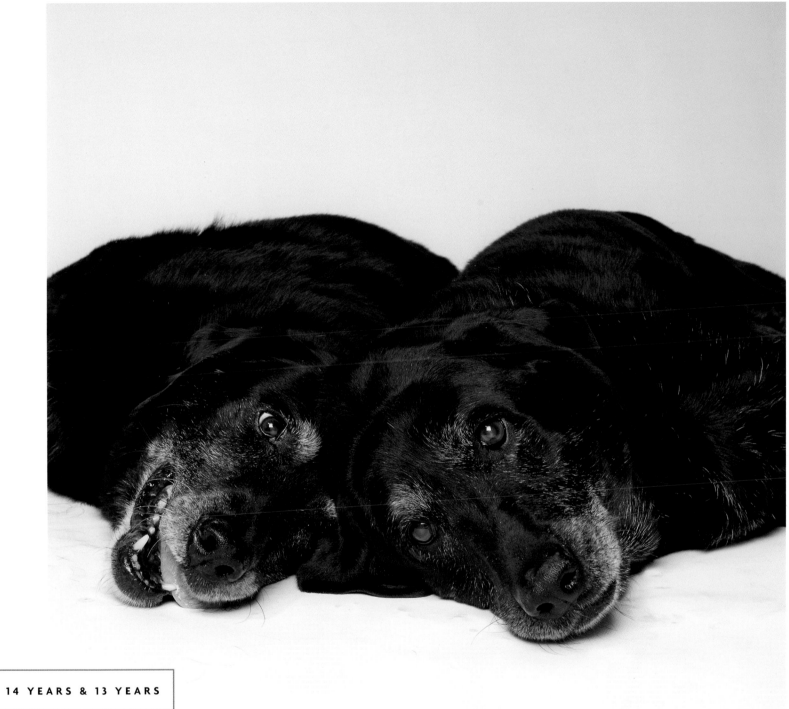

14 YEARS & 13 YEARS

Nellie

MIXED BREED

Nellie was a stray in Berkeley. One rainy night she just jumped into a friend's car as he was opening the door. Our friend knew we were looking to bring a dog into our lives. So we went to go see this little dog, part Beagle, part Border Collie. She's an exuberant little dog and she just ran right into me. Bam! That was it. We got our dog and the inspiration for *The Bark* magazine all at once.

She is a very friendly dog and that's what makes her very special to us. It's how she embraces life. She connects with humans whether they like it or not. She is the most people-friendly dog we have ever seen.

She has introduced us to a whole new world of dogs and dog lovers. If we had gotten a different dog, *The Bark* magazine might never have happened. Her approach to the world and her lust for life have a huge impact on the spirit of the magazine. It's all because of Nell.

CAMERON WOO & CLAUDIA KAWCZYNSKA

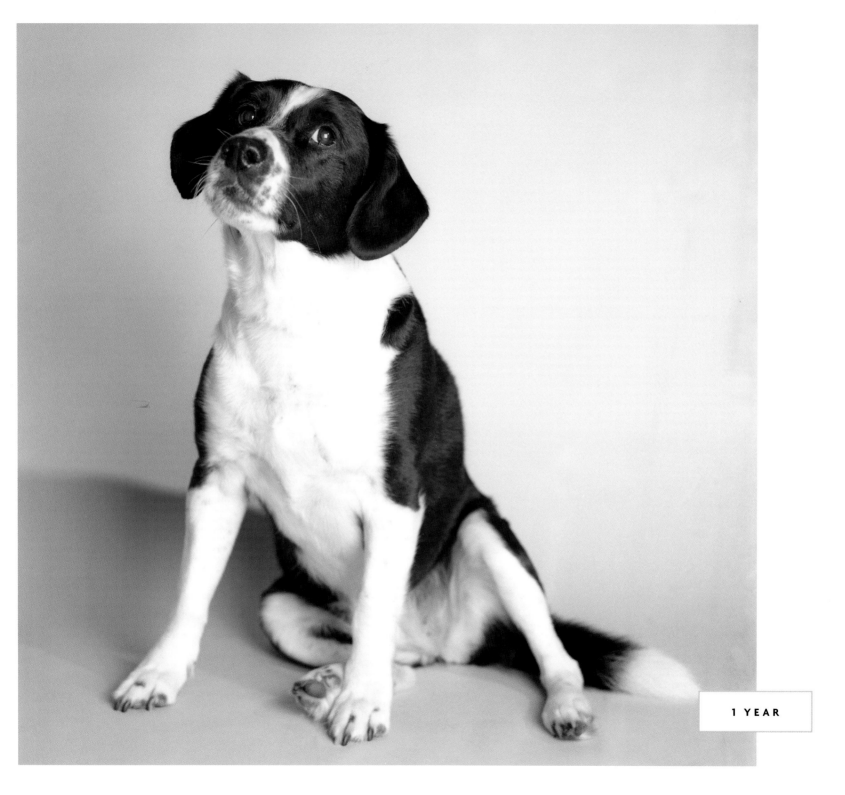

1 YEAR

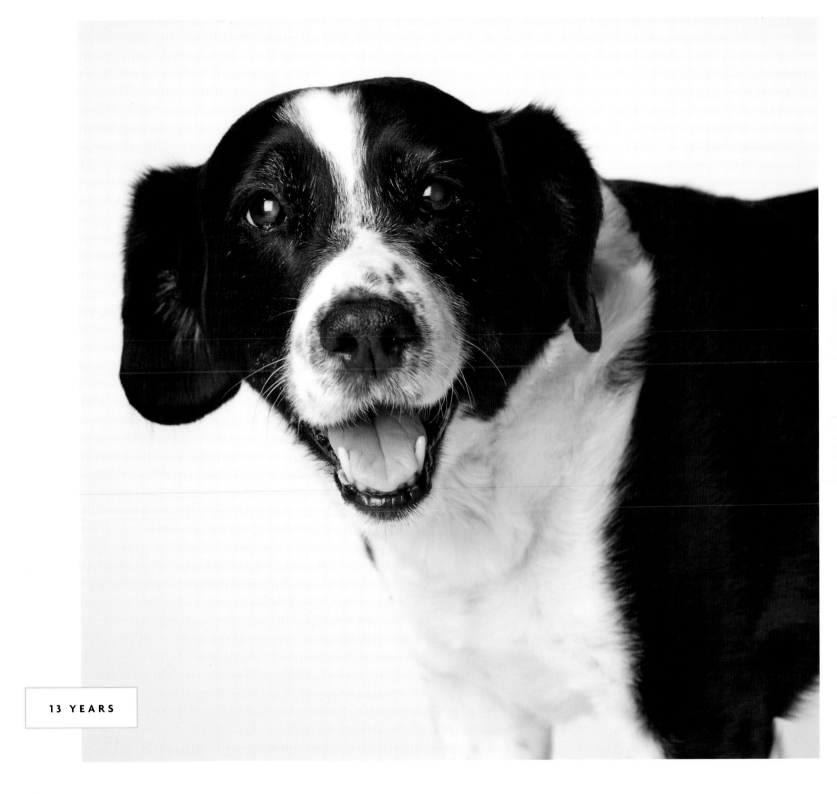

13 YEARS

Fred

PUG

We got Fred after my husband and I had been married for ten years. We decided we wanted to have a bit more responsibility in our lives. I always thought pugs were adorable and knew that was the breed for me. We've met so many people in our building in New York through Fred. Nobody can walk by a pug puppy and not stop and say hello. He thought his name was "You're So Cute" for a long time.

He is such a good listener. He tilts his head and I always feel that he knows what I am saying. He loves you no matter what you say to him. He doesn't ever get bored of you or think what you are saying is silly. I mean what other relationship do you have that allows that to happen?

JENNIFER BROWN

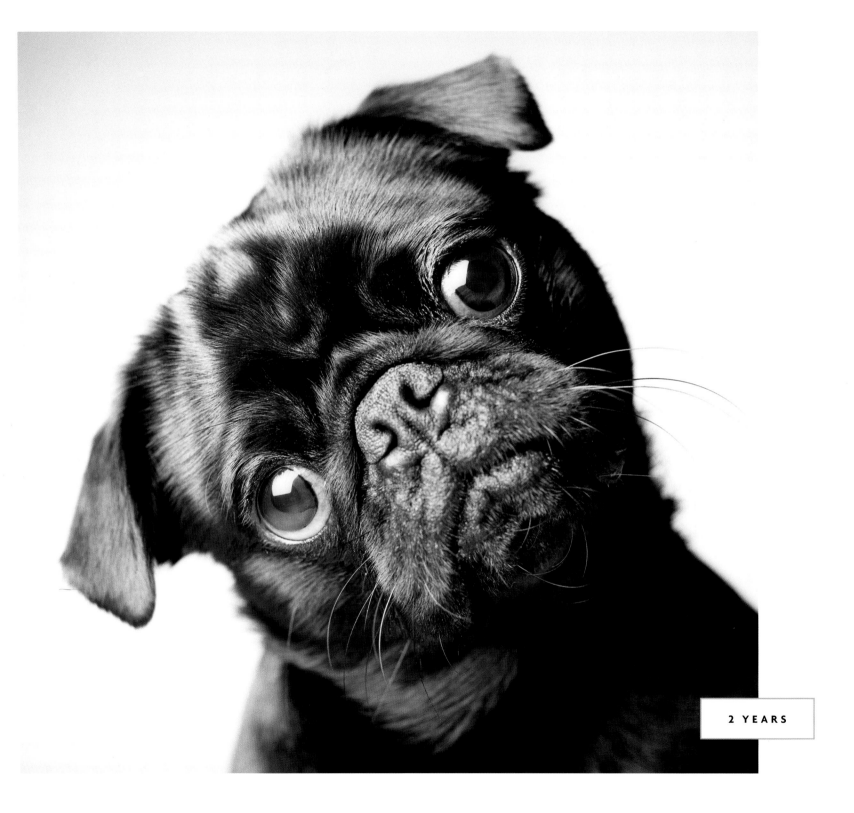

2 YEARS

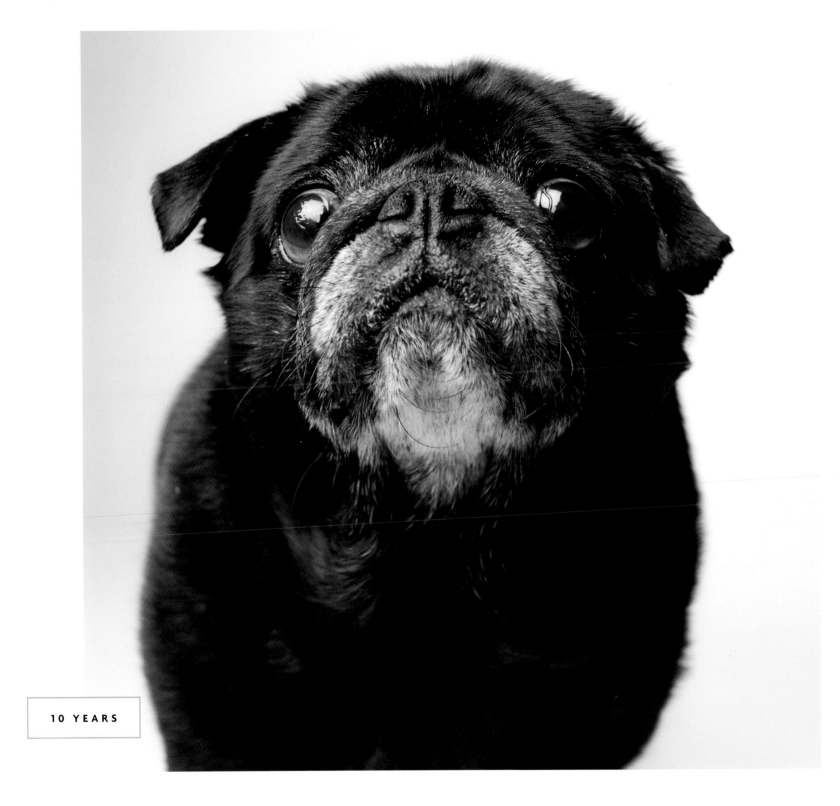

10 YEARS

Copper

BLOODHOUND

Copper reminds me of the cowardly lion from *The Wizard of Oz*. He gives off a false bravado. He will bark and sound tough and loud, and then if he is challenged, he will cower and run off.

He loves nothing more than to come up and put his head on your lap when you are sitting on the couch. He loves to have his face and ears rubbed.

My favorite part about Copper is the way he connects through eye contact. He looks right into your eyes and you can see that there is somebody special there. He speaks with his eyes. He tells me that he loves me or that there is something he wants. It is the way we communicate with each other. When we are having these connected moments I feel that there is a person in there.

ROBIN SNELL

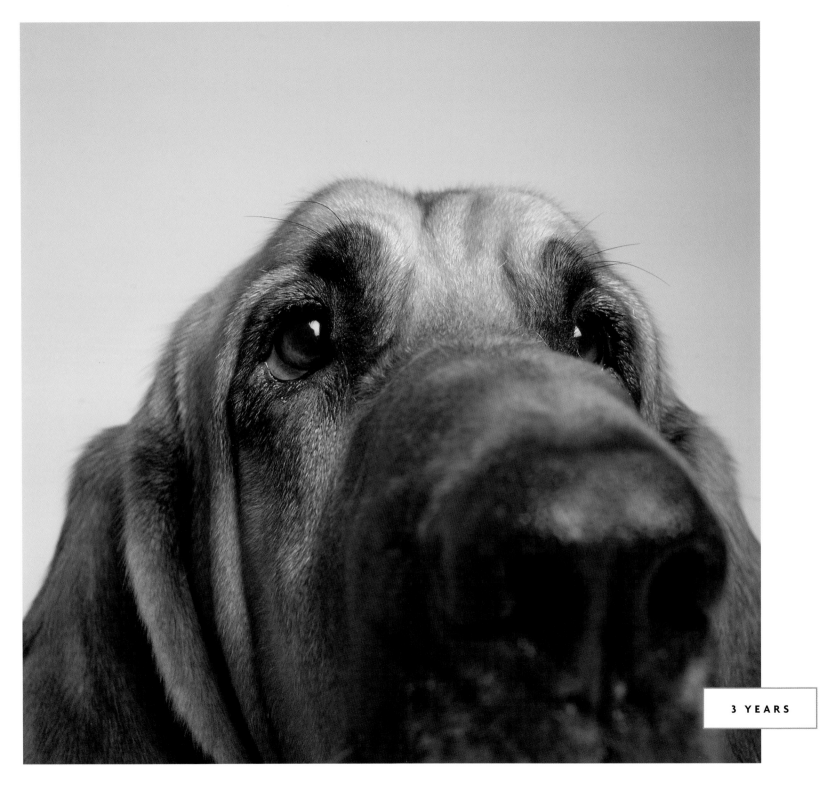

3 YEARS

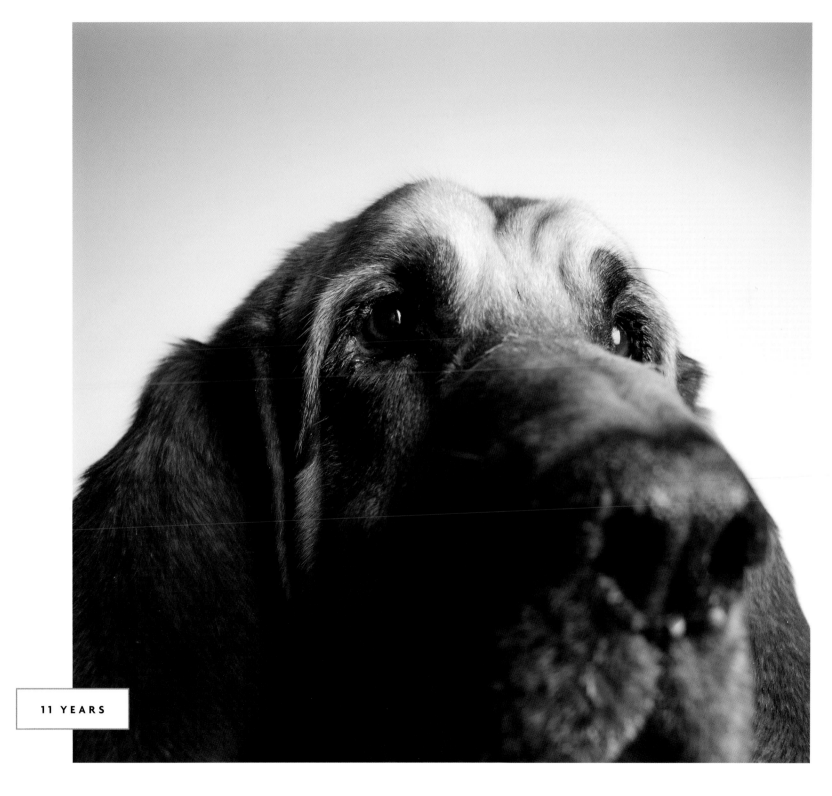

11 YEARS

Kayden & Brody

GREAT DANE & RHODESIAN RIDGEBACK

Great Danes grow so fast. It's amazing and so, so fun. It's like watching Bambi on ice! They grow unevenly. Like the back end would get higher one week and then her head would shoot up the next. She stops people dead in their tracks. We can't get five feet on a walk. That took some getting used to. So did all of the Great Dane jokes. "Does she have a saddle?"

Kayden grew past Brody very quickly. They played together from the beginning. It was very funny to watch Brody react to how big Kayden was getting. They have a lovely relationship. Brody is as loyal as they come and totally devoted to me, and Kayden is like my baby. There is no dog on earth like her. There is something really special about her.

DAWN PAULSEN

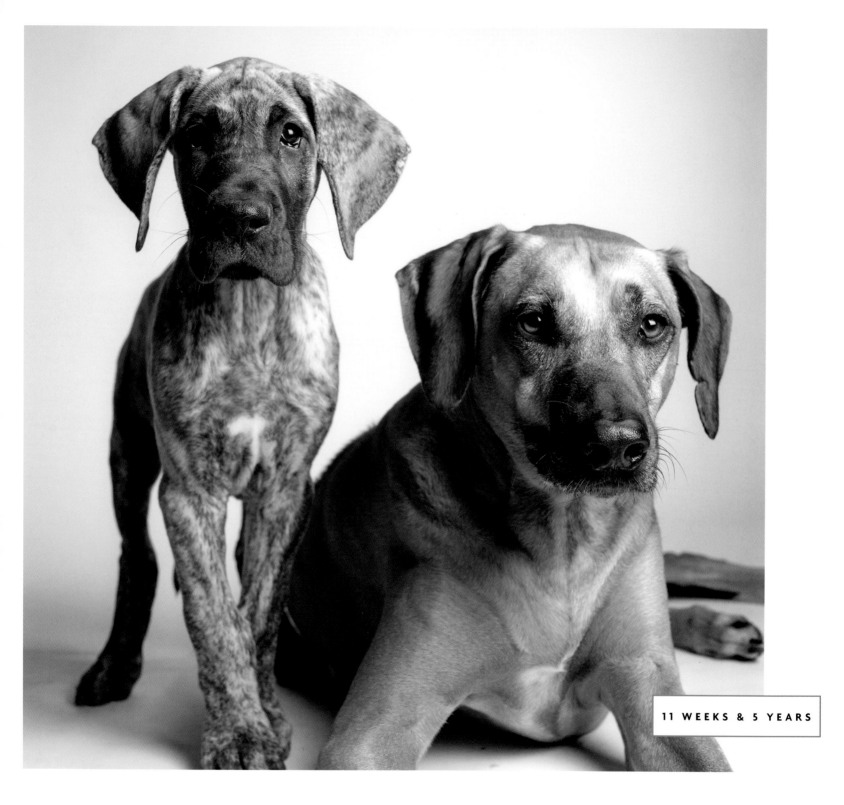

11 WEEKS & 5 YEARS

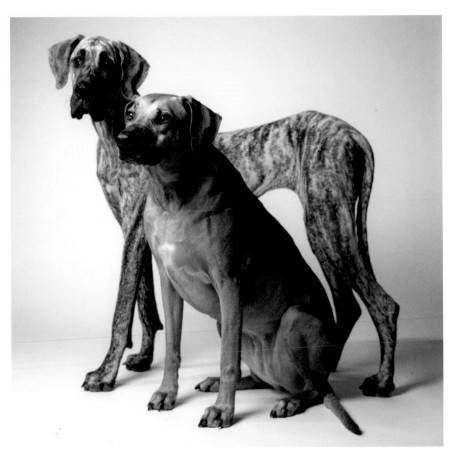

1 YEAR & 6 YEARS

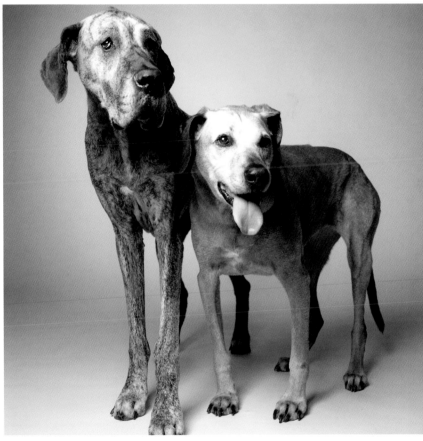

7 YEARS & 13 YEARS

Briscoe

BRUSSELLS GRIFFON

It was so hard to pick out a dog, until I noticed Briscoe. He was the only dog that was hanging out with an adult Whippet. He just seemed so smart and social.

I did not know what to do with a new dog. I was such a novice. He really trained me. We would go to the small dog park every morning at eight. Through him, I started to meet the greatest group of people.

Briscoe helps me get out of the apartment and be more social. Our walks bring me so much joy. He makes me a happier and a better person.

JESSICA PELL

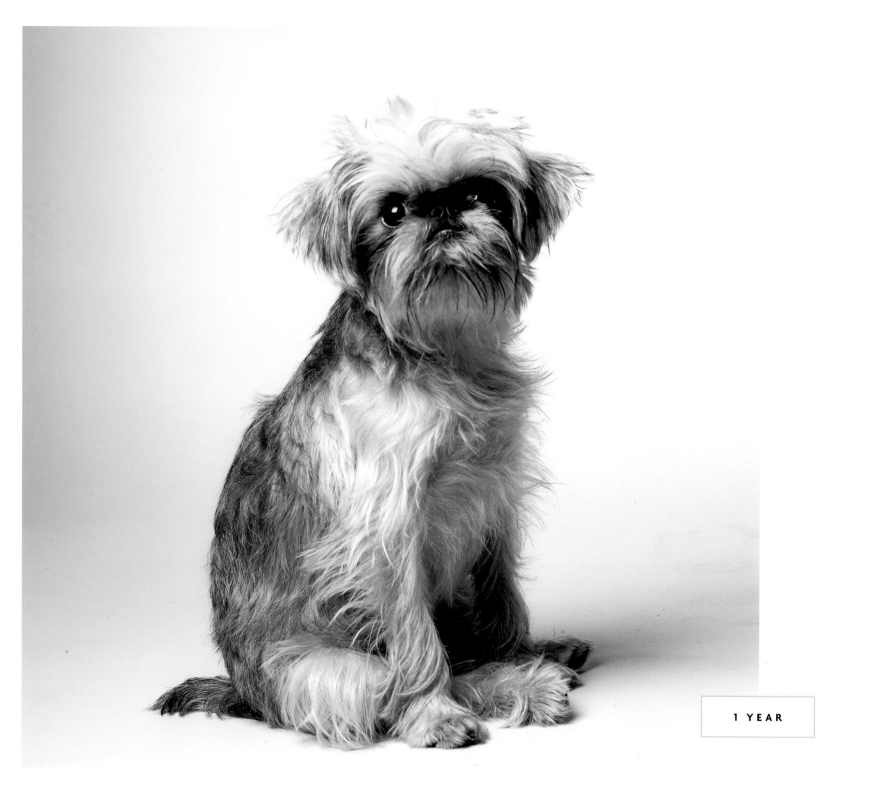

1 YEAR

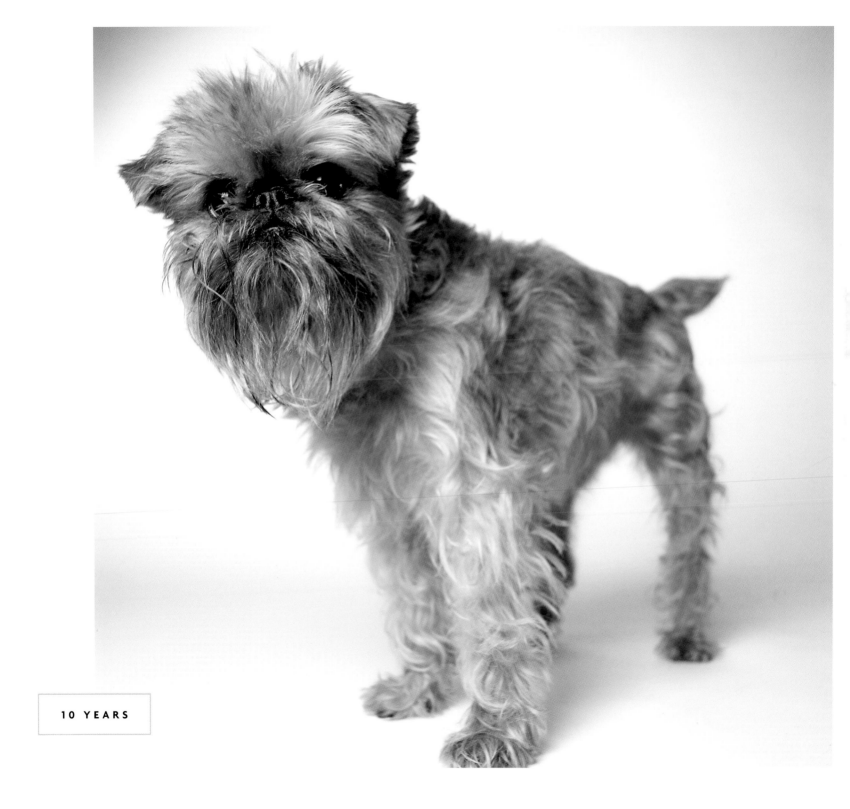

10 YEARS

Bella

CAIRN TERRIER

I originally brought home two puppies, Bella and her brother. Well . . . they made me crazy. It was too much. The little boy puppy was a madman and Bella was so quiet and calm. So after about two weeks my friend convinced me that I had to take one back. So I did. We kept Bella. Her honesty is beautiful. If you are petting her and she decides she's finished, she just walks away. The terrier heart—I love it.

She has a natural ability to hunt and runs off into the woods searching for wild chipmunks, mice, or any local vermin. We always think that if she ever gets lost and has to survive on her own in the wild, she could totally do it.

I mourned when she lost her sight. The eye specialist was very matter of fact about it: "Her retinas are gone. But she will adjust, no problem." And she has. She still explores the woods; she just does it with her nose.

KATE CHILDS

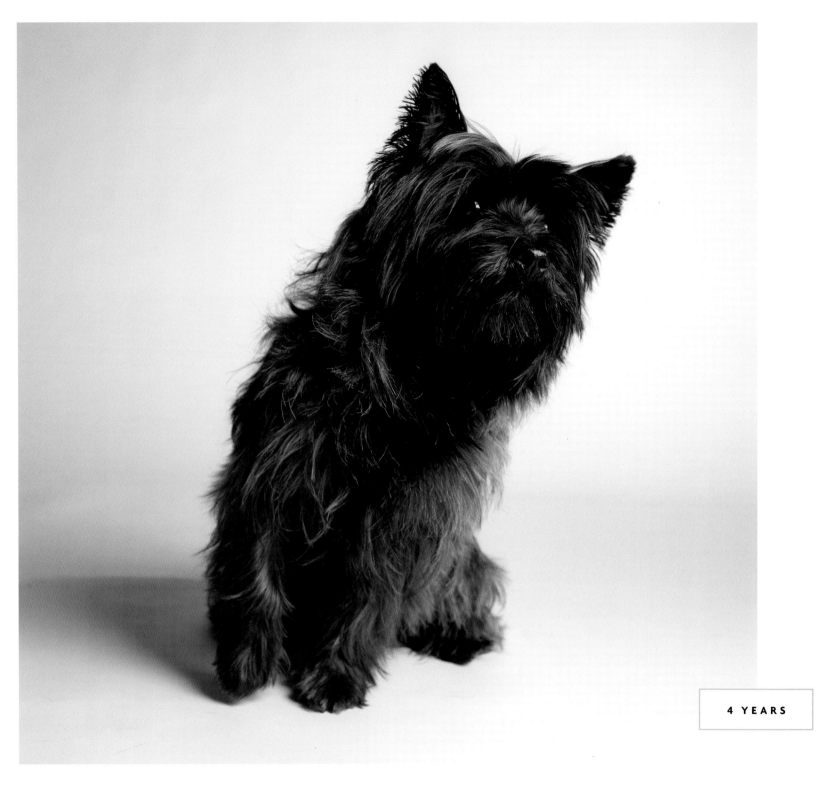

4 YEARS

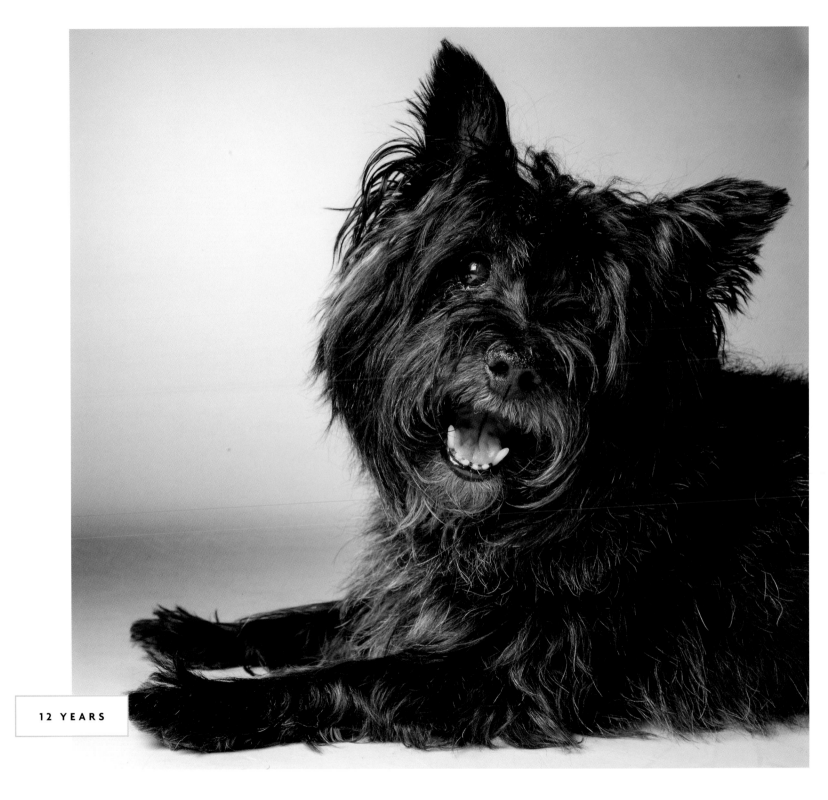

12 YEARS

Audrey

ITALIAN GREYHOUND

Audrey likes sitting in coffee shops because of the people watching, the good smells, and the attention that she gets. She loves to work the room. She goes over to people and just introduces herself. She is not looking for food, just looking to meet them.

She was very shy as a puppy—so little and frightened of everything. Now she has a list of dog friends that she looks for on her walks. She likes it best when everyone is on their leash and etiquette boundaries are respected.

ALLISON MCCABE

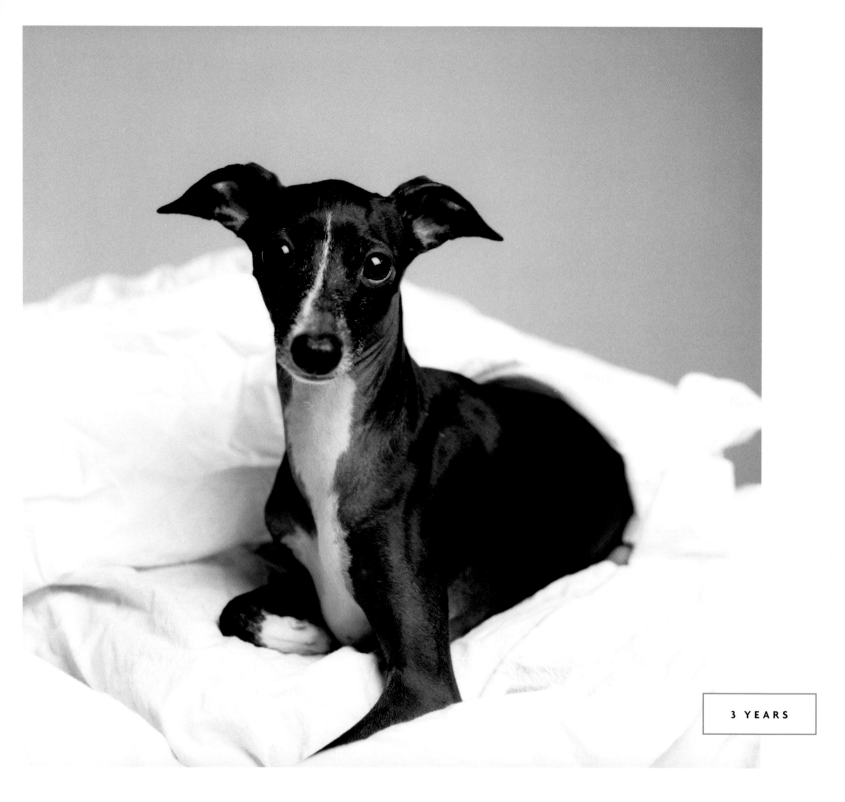

3 YEARS

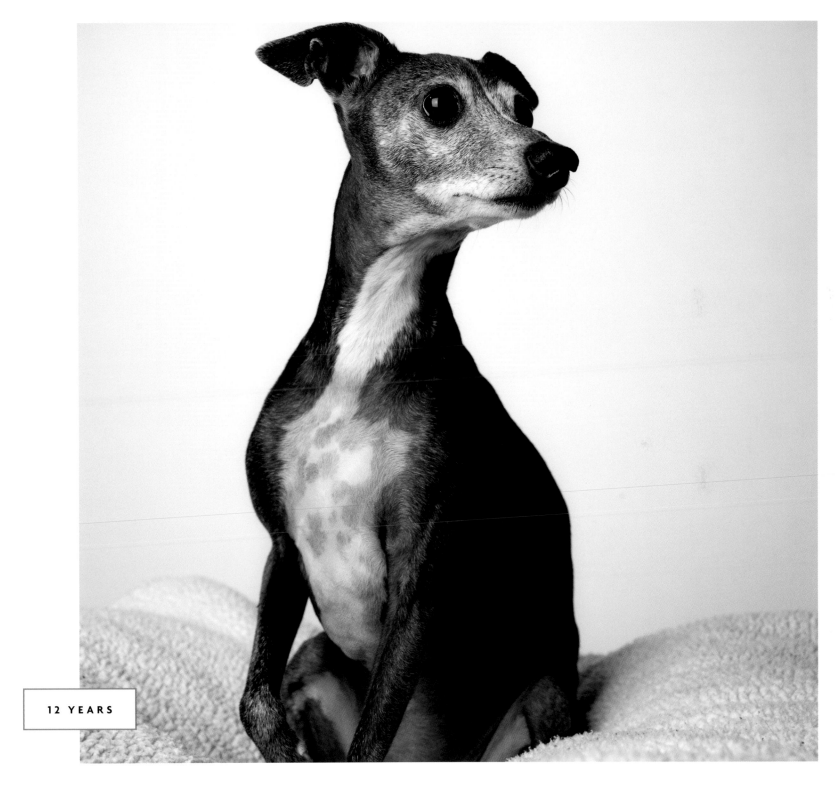

12 YEARS

Rudy

BRITTANY

Rudy is a very emotional dog. Whenever I am upset or crying, he comes right over and cuddles into me. He is my companion and my comforter. We call him "The Baby."

I love him so much.

MARY XANTHOS

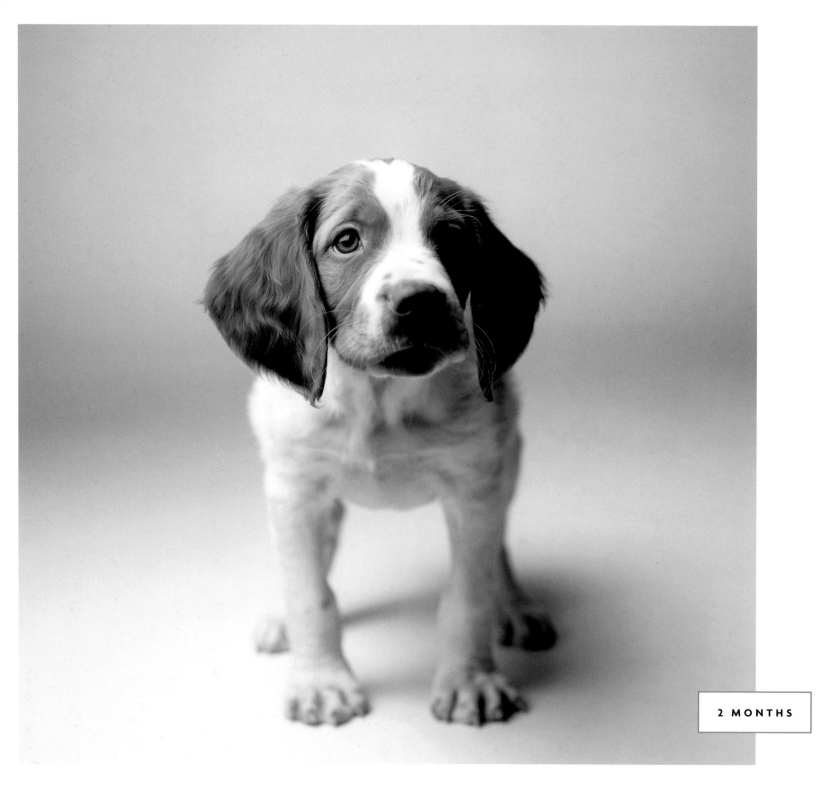

2 MONTHS

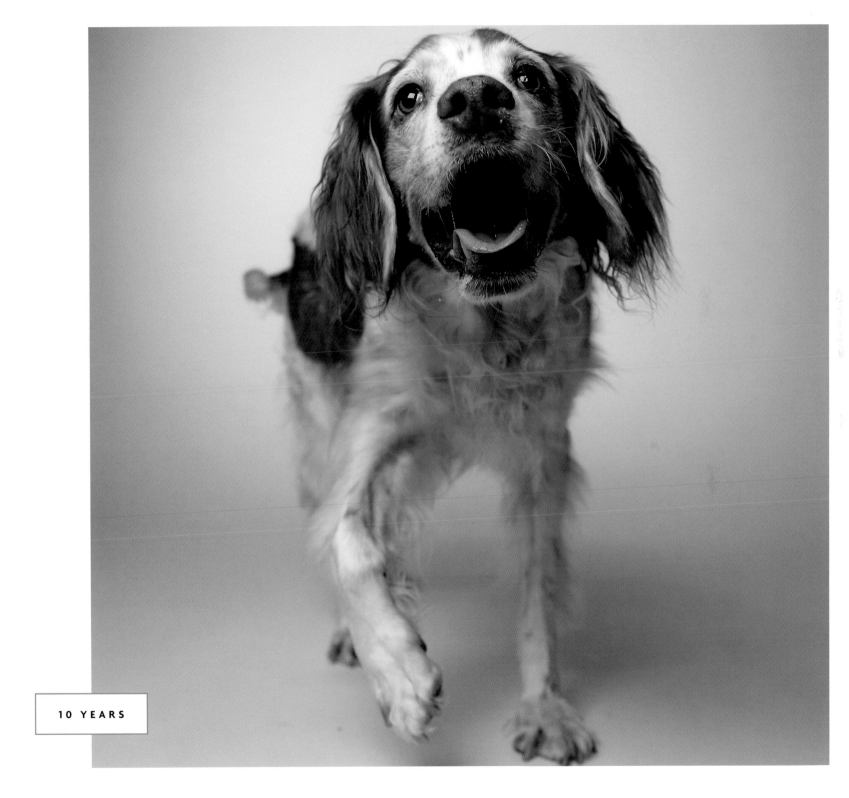

10 YEARS

Petey

WIREHAIRED DACHSHUND

We brought Petey home as a young puppy and he was just a love. We had a 5-year-old cat with really bad heart trouble, and I thought, "Oh my, how is the cat going to handle this puppy?" But within the next few weeks they were playing. They would watch each other run around the house and wait and pounce on each other. They had a ball. The cat ended up living to 16 years of age and he and Petey had become just the best of friends. I think Petey truly extended the life of the cat by pure playtime.

VICKIE INA

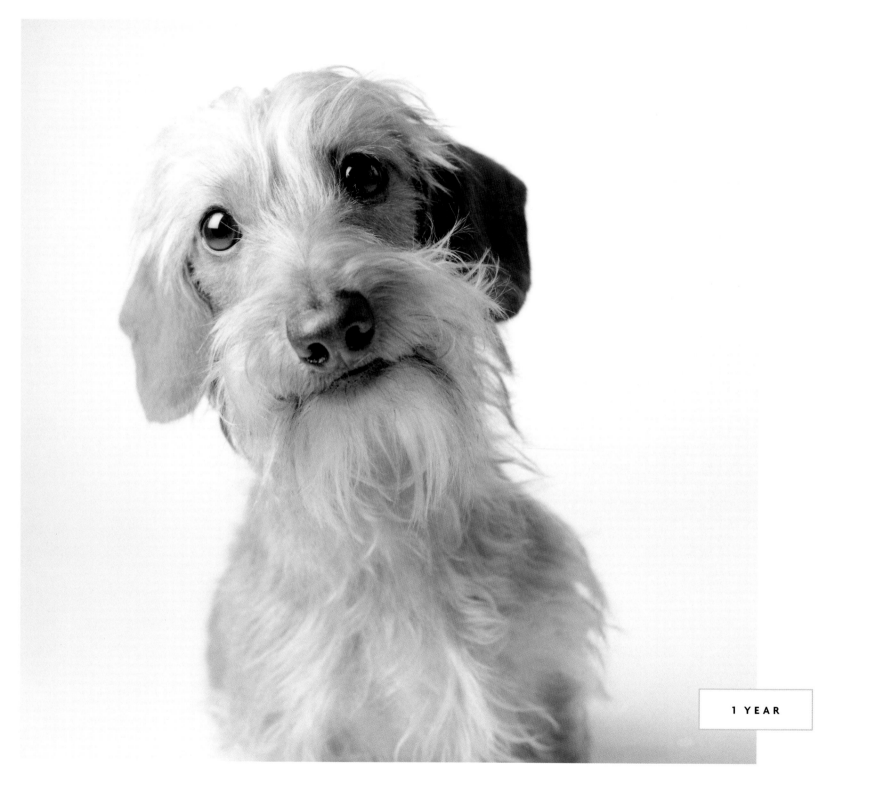

1 YEAR

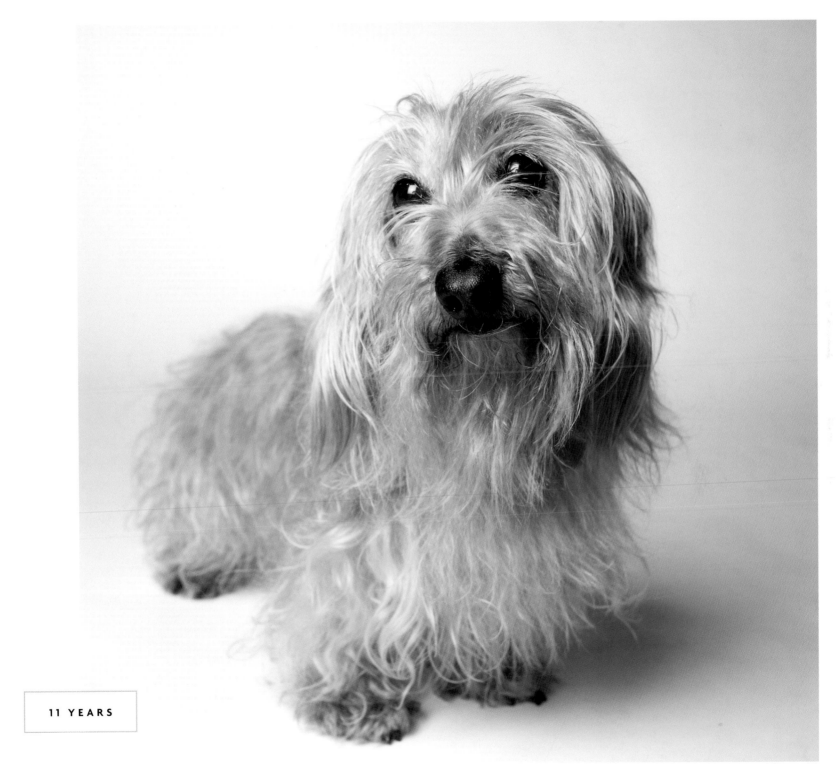

11 YEARS

Dao

FRENCH BULLDOG

Our fashion studio needed a dog. So we searched for a bulldog online. We saw an English Bulldog and a French Bulldog. The French Bulldog was photographed on a chair. When we asked why he was on the chair, they said that he was a rascal and would not sit for a picture. A rascal! That is exactly what we were looking for.

Dao is a clown in a dog's body. He has such a swagger as he walks the streets of New York City. Everybody in the neighborhood knows and loves him. There is no shortage of love in his life.

To me . . . he takes away all of my stress. My stress level in the fashion industry is very high. His little body just seems to take it all out of me at the end of the day. We have a friendship that is really unique. I speak to him like a human and he responds really well to it. He is my spiritual guidance. *Dao* is "the way" and he certainly has lived up to his name. Dogs give us something that other people can't.

TUNJI DADA

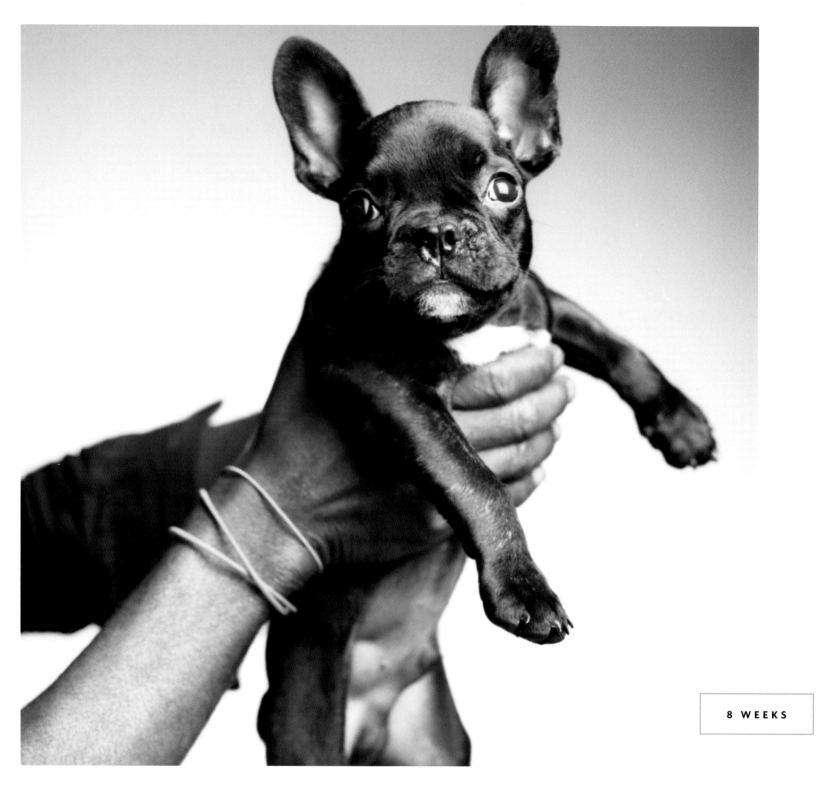

8 WEEKS

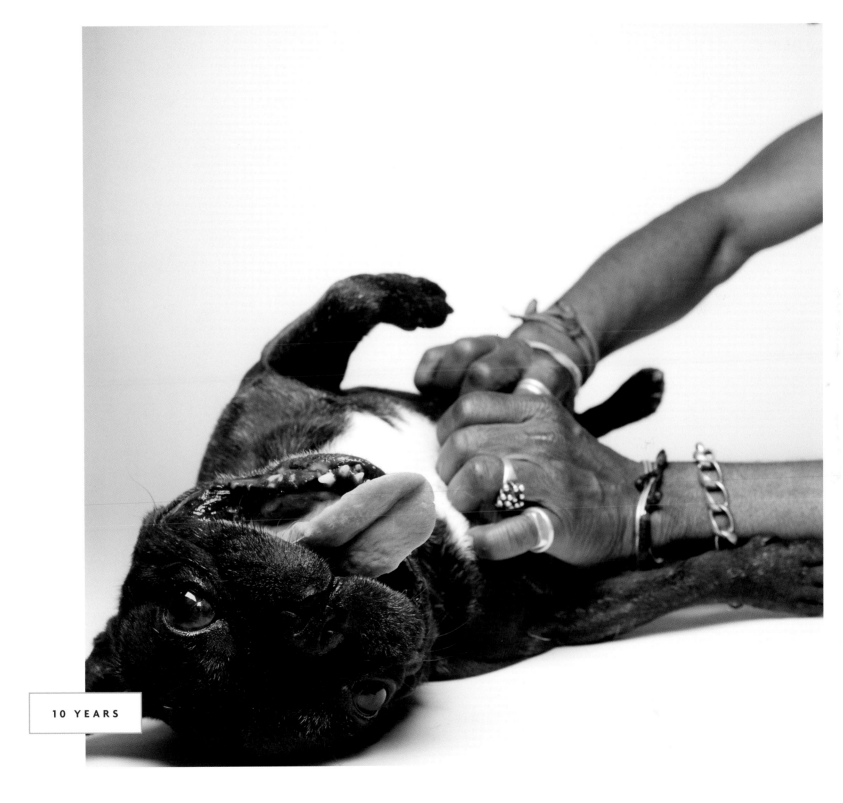

10 YEARS

Lily Lily is Amanda Jones's first dog and the inspiration for this book. She leads a charmed existence highlighted by loads of baby carrots and lots of belly rubs. She lives in the Berkshire Mountains of Western Massachusetts.

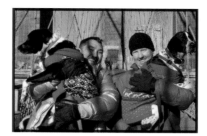

Gus & Liza Gus moved from Minnesota to New York City in January of 2005. Liza has always known New York to be home, though she was born in Oregon. Gus is an easygoing, fun-loving dog. Liza is a good-natured, affectionate dog, who patiently puts up with constant attention from her human sister Harper.

Georgia Georgia lived in San Francisco as a puppy, but made a big move to Los Angeles when she was 12. She's become a glamorous retired lady, spending her years tanning and kissing babies. She loves to swim, walk, run, snuggle, and eat toast.

Maddy Maddy is a worldly Border Collie–Husky mix who has lived in North Carolina, Utah, Connecticut, and New York. She was rescued from Chapel Hill and the grips of the Tar Heels, and raised in Durham as a proper Blue Devil.

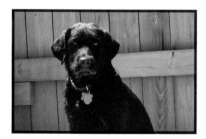

Corbet Corbet is the canine matriarch of her family, which includes her human mom Kim Wright and her Goldendoodle siblings, brother Clarke and sister Callie. She is a rowdy retriever when it comes to fetching in the water, especially in the Rappahannock River and Nantucket Sound.

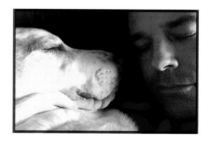

Poppy Poppy is a lemon-and-white Basset Hound who loves her down time on Ahmic Lake in Muskoka, Canada. She rolls out by the water's edge, belly up, and stretches before the sun and stars on most summer days. She has always been an international traveler between the Berkshires and Ontario.

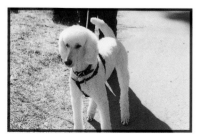

Gracie Gracie shares an old Victorian in San Francisco with her owner Aileen Arrieta.

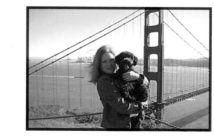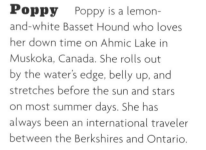

Rufus Rufus was born and raised in San Francisco, and he is named after his owner's favorite funk band. While his breed—Cockapoo—may sound fussy, he's a cool, funky dude. He can work a room or the park like nobody's business. His age is catching up with him a bit, but he still has his mojo working.

Mochi & Olive Mochi & Olive love to dress up in the costumes their owners Lisa & Woody make for them. They are little attention-seekers and love the commotion they make when wearing them. Mochi & Olive go on road trips and out to eat as much as they can. Strangers know them by name.

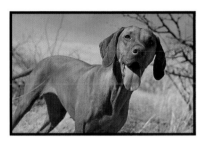

Rumer Brilliant, beautiful, athletic, charming, Rumer can work a room and make every person believe they are the most fascinating human she's ever met. She mesmerizes judges in the show ring, hunts with abandon, and plays in the ocean, all with the same enthusiasm. She is a force of nature.

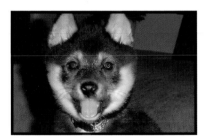

Abigale Abby is a 10-year-old Shiba Inu and she enjoys life in Tucson, Arizona. Fondly known as "Alpha Girl," she keeps her compadres, Jake and Rudi, in line. Abby is a certified pet therapy dog and she loves to brighten one's day.

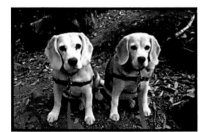

Sydney & Savannah
The Beagle sisters, Sydney & Savannah, live in Mill Valley, California, where their outgoing nature and terminal cuteness often brighten the faces of even the crankiest adults and children they run into. They're always full of surprises, keeping their people, Judith and Chris, entertained but constantly on their toes.

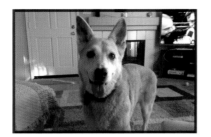

Zamboni Zamboni is a 16-year-old Shepherd–Husky mix raised in Arizona and Indiana, but who mostly calls California his home. He loves swimming in the pool and going to the park to frolic off-leash. He's an independent dog that loves his space, but he also loves being in the vicinity of his dad as much as possible.

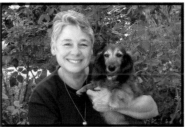

Violet When Violet came to her home in San Francisco, she loved her garden. When she moved to Sonoma County, her yard was much bigger so she likes it even more. She is sweet as sugar, shy, and selective about her favorite people. She has moved to the country and become "gopher girl" of Forestville, California.

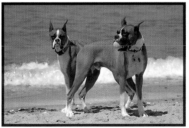

Winston & Lola
Whether playing fetch in New York City parks, frolicking endlessly on Nantucket beaches, strolling to work in SoHo, or being led through their West Village neighborhood by their owners' kids (who are half their height), Winston & Lola have been sustaining sources of warmth, joy, laughter, and humanity.

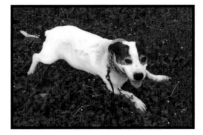

Vasco Vasco isn't well-behaved or easygoing, but he is funny, wily, surly, charming, and he has a personality far bigger than his long–short body should be able to hold. Karen feels incredibly lucky to be able to spend so many years with him.

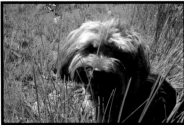

Halle Born in Ireland, Halle has lived in San Jose, New Orleans, and now New York City's Upper West Side. These days, you will find her walking through Riverside Park greeting her many canine friends. She is equally comfortable digging in the sand at a beach as she is dining alfresco at a sidewalk café. Her guardian, Mary, delights in every day, every walk, she shares with Halle.

Nellie Nellie is a Border Collie–Beagle mix who inspired her humans to launch *The Bark* magazine back in 1997. The magazine takes its cues from her—smart, headstrong, and congenial. She is a dog that turns every glancing look into a chance for pats and a howl.

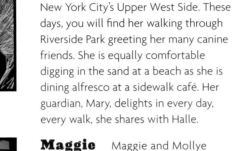

Maggie Maggie and Mollye Wolahan found each other in Colorado in 2004, after Maggie was rescued from a puppy mill. Their intense bond was immediate and has never wavered. Maggie and Mollye have lived in Western Massachusetts since 2008 with Maggie's other favorite human, Todd, and Maggie's favorite cat, Tiger.

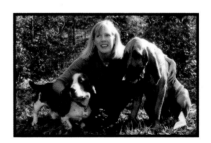

Fred Fred is an 11-year-old Pug. He loves to eat, take naps, and play fetch with his favorite toy chicken. He works tirelessly to keep the floors free of crumbs dropped by toddlers. He lives in Brooklyn, New York, with his family.

Tyson You can usually find Tyson lounging in the grass on a sunny day or chasing squirrels in the backyard, strolling along Theodore Roosevelt Island, or playing a fierce game of tug-of-war with his sidekick and partner-in-crime, Dixie.

Copper Copper is a formidable 140 pounds and can appear quite intimidating because of his size, but he is a softie, reminding his owner of the cowardly lion in *The Wizard of Oz*. He loves being a house dog and a family pet, and appreciates snuggles and pats.

Maddie & Elle Maddie & Ellie live in New York City and Pound Ridge, New York. It is the perfect mixture—the sophistication of city life and the beauty and space of the country. Maddie is certainly the "Alpha Dog," but only because Ellie allows her to be. They adore each other.

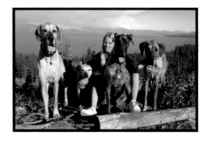

Kayden & Brody Brody and Kayden live happily in Santa Monica, California, with their adoring mom and two younger Great Dane sisters, Spencer and Ryan. Brody can usually be found in her favorite spot, which is on the couch waiting for her servants to bring her McDonald's cheeseburgers. Kayden loves to bask in the sun and roll in the grass.

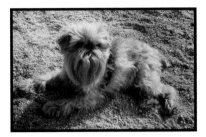

Briscoe Briscoe tries to go to the Washington Square Park dog run every day. He likes to hang out with the owners more than the dogs. No one likes chopped liver on the Jewish holidays more than Briscoe.

Petey Petey loves sleeping between his owner's knees (either above or beneath the comforter). His blonde hair fits in well with the California surf that is in his backyard. Kisses flow when he's held by friends and family, but especially for his mom and dad.

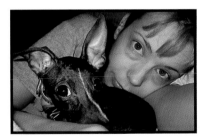

Bella Bella loves long walks in the woods, hunting wild chipmunks, and eating anything she can find. She enjoys sleeping and lazy sunbathing on the deck of her home in western Massachusetts. She is (mostly) very well behaved.

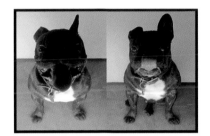

Dao
Dao is a French Bulldog and his first priority always is to entertain, especially kids with their toys. He is without a doubt a healing clown and a best friend.

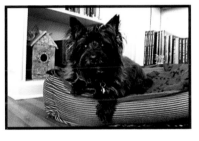

Audrey Audrey is an Italian Greyhound, a picky eater, and she can locate a coffee bar in any city. She gives the best hugs and she lives in New York City with her people, Allison McCabe and Michael Mertens.

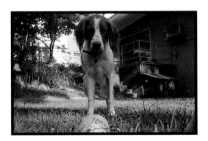

Rudy Rudy is a 10-year-old Brittany born and raised in New York. He enjoys visiting the tennis courts in Central Park, where no lost tennis ball is safe from his nose; swimming in the North Woods; and hiking through the Ramble of Central Park, forever on the lookout for squirrels.

ACKNOWLEDGMENTS

My work, resulting in this book, has kept me creatively engaged for twenty years. During that time, a few people have kept me going.

Chris Jones, my husband, partner, and greatest champion of my work—the combination of your enthusiasm and a great cup of coffee in the morning make you invaluable.

Mary Virginia Swanson, my friend and teacher—you taught me that a career in photography was possible and then you helped me move it forward! Thank you.

Megan Minkiewicz, a guide dog puppy trainer and dear friend—you always picked up your phone and talked dog when needed. This book would be half what it is without you.

Wynn Rankin, my editor and production partner on *Dog Years*—you shaped an idea into a lovely final product. Thank you for your enthusiasm and hard work on this book.

Benny, my current dog and loyal studio partner—a warm belly to rub after a long day should never be undervalued.